CONSTABLE
and his world

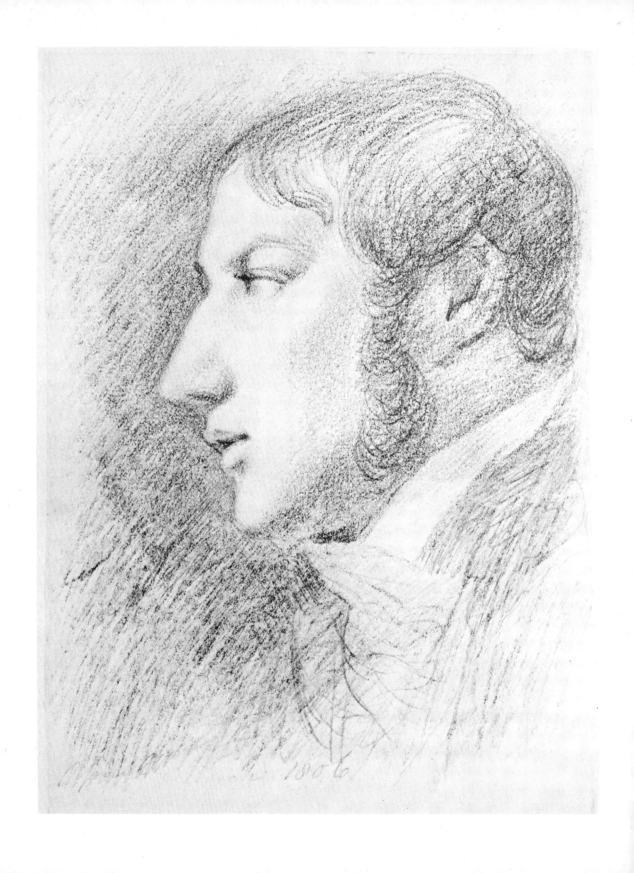

REG GADNEY

CONSTABLE
and his world

W. W. NORTON & COMPANY, INC.

NEW YORK

John Constable, a self-portrait
drawn in 1806, when the artist was
thirty.

ISBN 0-393-04440-8

Printed in Great Britain by
Butler and Tanner Ltd
Frome and London

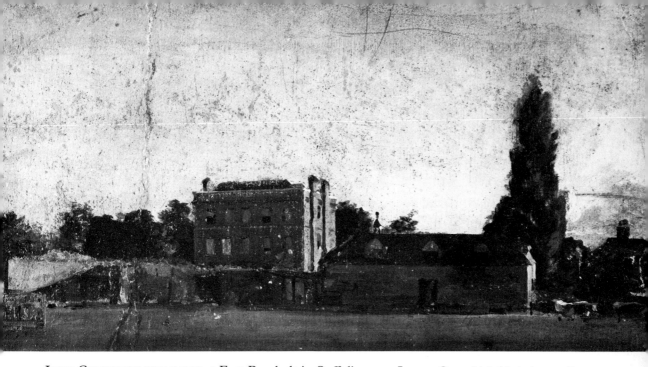

JOHN CONSTABLE WAS BORN at East Bergholt in Suffolk on 11 June 1776, the fourth child and second son of Ann Constable whose husband, Golding, was a prosperous local corn merchant. His birthplace, East Bergholt House, stood at the heart of those twelve square miles or so in the valley of the river Stour, the boundary of Suffolk with Essex, which even during his own lifetime was to become known popularly as the Constable Country. Although Constable's view of English landscape scenery eventually widened to include the natural surroundings of Salisbury, Brighton, Hampstead and some other districts of early nineteenth-century England, the Constable Country remains at the centre of what we may call the world of John Constable.

In some ways this world was a rather small one: his family, his love of landscape and his art were its main constituents. Unlike his great contemporary Turner, Constable never went abroad; indeed, he only once went to sea and even then the ship hardly left the English coast; and although he spent the greater part of his professional or working life in London his devotion was to rural rather than to metropolitan scenery. This view of Constable as a man devoted to painting the attractive countryside of England that he loved so much suited perfectly the purposes of his most celebrated biographer and friend, C. R. Leslie. His *Memoirs of the Life of John Constable, R A* (1843) is substantially composed of Constable's own letters and provides us with a powerful but largely imaginary sense of Constable's character and manner. Not surprisingly perhaps, Leslie brought the sympathetic but often injudicious editorship of a devoted admirer to bear upon his material; he allowed himself to

Constable's birthplace at East Bergholt, Golding Constable's house; detail of a painting done by Constable in about 1811. The house was pulled down in the early 1840s.

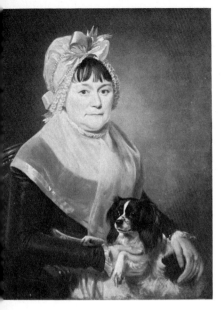

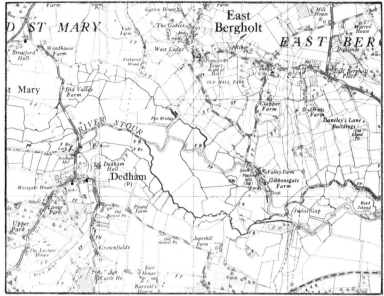

Ann Constable, the artist's
mother, painted in about 1801.

(*Above, right*)
Map of the twelve square miles or
so around the Stour valley, on the
border of Suffolk and Essex,
known as the Constable country.

round off and blur the edges of Constable's character. In 1886, a
less well-known, briefer but probably more apt conclusion was
reached by the brothers Redgrave who commented in *A Century
of Painters of the English School*:

Constable has been most fortunate in his biographer, but Leslie has painted
him *couleur de rose*, and transfused his own kindly and simple spirit into the
biography. The landscape painter, though of a manly nature, was eminently
sarcastic, and very clever at saying the bitterest things in a witty manner. This
had no doubt been increased by the neglect with which the would-be con-
noisseurs had treated his art, and the sneers of commonplace critics.

It is true that Constable had little time for connoisseurs, common-
place critics, society painters and amateur artists, and he could be
sarcastic; on the other hand, he was a good friend to a number
of artists more neglected than himself and certainly less gifted.
Nevertheless, Leslie's *Life* with its agreeable tones of *couleur de rose*
and the vast popular affection still afforded Constable's paintings
continue to encourage a forgetfulness that he was a highly ambitious
and often deeply troubled man. His family had misgivings about his
chosen career; so too did the family of the woman he loved and
eventually married. His artistic gifts developed very slowly, far
more so than those of his more precocious contemporaries, notably
Turner. The Royal Academy took a long time to recognize his
ability and for many years delayed electing him, thus postponing
the mark of professional recognition which in those days greatly
contributed to easing the difficulties which faced an artist seeking
financial independence. Obstacles such as these concerned him

greatly. They increased his recurrent fits of anxiety and depression, which in turn no doubt served to sharpen his tongue. But displays of either temperament or temper rarely attended the vicissitudes of his family life: he was a most loyal and loving husband and father.

When we consider Constable's paintings it is, perhaps, difficult for some to realize that the painter whose work now decorates biscuit tins, living rooms and beer advertisements was a revolutionary artist, acutely aware of the traditions of art and the problems of reconciling them with an almost obsessive affection for a particular kind of landscape. His final achievement was his depiction of the English countryside during a period of its greatest beauty; he recorded it with a directness and skill which prompted Leslie to call him, with no exaggeration, 'the most genuine painter of English landscape'.

The origins of Constable's feelings for what he most admired in English landscape and his depiction of it lay in the clear memories of his early years which he dwelt upon throughout his life. When he was forty-five he expressed them in a letter to his greatest friend, whom we will meet shortly, John Fisher:

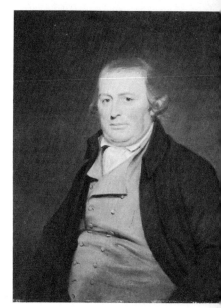

Golding Constable, miller, merchant and farmer, painted by his son John in 1815, the year before he died.

the sound of water escaping from Mill dams, ... Willows, Old rotten Banks, slimy posts, & brickwork. I love such things.... As long as I do paint I shall never cease to paint such Places.... Painting is but another word for feeling. I associate my 'careless boyhood' to all that lies on the banks of the *Stour*. They made me a painter (& I am gratefull).

Such comments, written from Hampstead overlooking early nineteenth-century London, are nostalgic and conservative; and certainly he was emotionally attached to Toryism throughout his mature life; yet his views on art were revolutionary. He revolted against the concepts of the Academicians, whose institution he so admired, because he felt their landscape painting was second-hand.

Constable describes the countryside which bears his name in the letterpress for the edition of published mezzotints based on his work by the engraver David Lucas. He tells of the effect of his childhood surroundings and leaves us in no doubt about his feelings for 'his own places'. He almost apologizes for the love he had for them, suggesting that

Perhaps the Author in his over-weaning affection for these scenes may estimate them too highly, and may have dwelt too exclusively upon them; but interwoven as they are with his thoughts, it would have been difficult to have avoided doing so; besides, every recollection associated with the Vale of Dedham must always be dear to him, and he delights to retrace those scenes, 'where once his careless childhood strayed' ... and where by a fortunate chance of events he early met those, by whose valuable and encouraging friendship he was invited to pursue his first youthful wish, and to realize his cherished hopes.

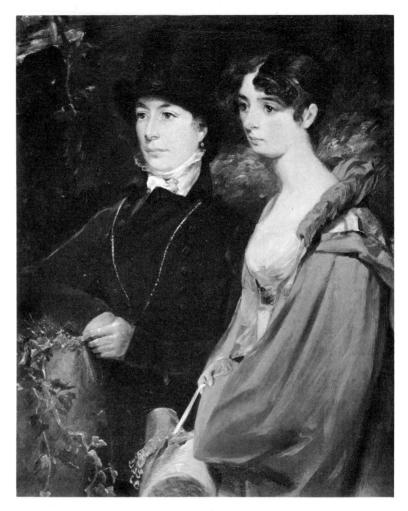

Ann and Mary Constable, two of the artist's sisters, painted about 1814, when Ann was forty-six and Mary thirty-three.

The affections, and the consequences of his professional and financial difficulties, characterize much of Constable's voluminous correspondence with his family, friends and acquaintances. His letters have been published in complete form only during the past few years, and from them we are able to gain a more precise impression of Constable's character and life than the one afforded to us by Leslie.

Constable's father, Golding, raised his children in an atmosphere of rural prosperity; he owned corn and coal warehouses, some rich farmland, corn mills and two corn-carrying vessels. By all accounts he was a successful businessman who treated his employees thoughtfully, and would doubtless have applauded the famous phrase of the contemporary agricultural commentator Arthur Young: 'the magic of property turns sand into gold'. When John Constable described the topography of East Bergholt he noticed it was 'most cultivated' and 'fertile' – features which in no small way

contributed to his own security and upbringing. Golding Constable made business trips to London reluctantly; he said he found the air oppressive beyond the Essex town of Ilford. It was probably on such a trip he met Ann Watts. The couple married in 1767 and Ann added her own personal wealth to that of her husband. She bore him six children. The eldest, Ann (b.1768), eventually devoted her affections to dogs and horses; Martha (b.1769) was the only daughter who eventually married; Golding (b.1774), the eldest son, should have taken over the family business but seems to have been mentally retarded. When his family numbered five, Golding Constable decided to build his own house, a three-storey affair in red brick on East Bergholt's main street to which were attached thirty-seven acres of land. The family moved in during 1774, and two years later the second son, John, was born. In 1781, Ann had another child, Mary; she, like her elder sister, was to devote her affections to animals. Judging from Constable's portrait of his two sisters, Mary seems to have been the more conspicuously feminine of the two girls. No painting of Martha has been recorded. In 1783, when she was thirty-five, Ann bore Golding Constable his third son, Abram. He turned out to be everything his father wanted of a son; he ran the business with considerable if cautious and worried efficiency, and with his very good looks and friendly manner endeared himself to everyone he met. A loving brother to John, he never married.

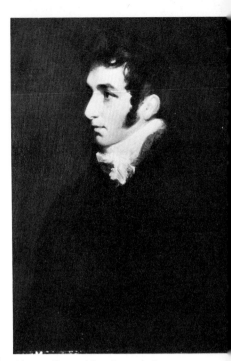

Abram Constable, the artist's younger brother, in his early twenties, about 1806.

At the age of seven John was sent to a boarding school some fifteen miles from East Bergholt, and not long afterwards he went on to another school in Lavenham. Here, along with his fellow pupils, he was all but ignored by the headmaster, Mr Blower, who, according to Leslie, was in love and handed over his teaching to an usher. While Blower was away with his woman the usher earned John's lasting hatred by administering repeated floggings. The boy was promptly removed, having formed a dislike of boarding schools and corporal punishment which remained with him throughout his life. He was now enrolled at the grammar school at Dedham, and here he was more fortunate.

Each morning his walk to school took him along the lane which he later used in the foreground of *The Cornfield* and through the fields to lessons given by the Rev. Thomas Grimwood, who, according to Leslie, shortly realized that John's gifts were for drawing rather than writing. His father reached much the same conclusion, gave up the idea of educating his son for the Church, and instead, as Leslie recorded, 'determined to make a miller of him'. In normal circumstances the eldest son, Golding, would have undergone the training prior to taking on his father's business. But Golding was incapable. Therefore, for about a year, it fell to John's lot to be taught the miller's skills.

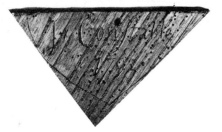

A fragment from the windmill where Constable worked, bearing his name carved with a penknife and the date, 1792.

One of the mills at East Bergholt, not far from Pitt's Farm, in which he underwent this rigorous training, appears in the distance in two of his paintings (*Golding Constable's Kitchen Garden*, 1815, and *Spring Ploughing, East Bergholt*, c. 1816). A timber from the mill is now preserved in the Colchester Minories. It bears the carved inscription 'J. Constable, 1792'. From this mill, constructed against a living tree, John looked out at the sky to scan the clouds for signs of different forces of the wind. David Lucas said: 'From this mill his earliest observations on atmospheric phenomena were made, and his own deep knowledge acquired that so materially contributed to his successful practice.' This training enabled Constable to learn to see the cloud formations with a disciplined eye equalled in rigour by few artists before or since. Of the remainder of his miller's training we know little. Probably he was instructed in book-keeping, but it is unlikely he showed much interest in it.

In his spare time he made friends with a local plumber and glazier, John Dunthorne, whose hobby was sketching. Constable joined Dunthorne on his expeditions in the neighbourhood, and frequently returned to complete his efforts in Dunthorne's cottage. Golding Constable seems to have raised no strong objections to his son's pursuit and even, apparently, viewed it with some amusement. Lucas tells us:

Both Dunthorne and Constable were very methodical in their practice, taking their easels with them into the fields and painting one view only for a certain time each day. When the shadows from objects changed, their sketching was postponed until the same hour next day.

When eventually the seemingly inseparable pair returned home, Golding Constable would declare: 'Here comes Don Quixote with his man Friday.'

The scenes Constable chose were pleasant and attractive but not of spectacular natural beauty. He chose them because of course they were familiar and near to home and because they were also shaped by the profitable business of agriculture, a business to which, as we have seen, he owed his own well-being and security: tow-horses making their way along the tow-path, tugging the barges along at no more than two miles an hour; cornfields, water-meadows, pasture-land. The landscape was cared for and tended – much of it by his own family's agricultural workers – and the soil, 'a vein of friable, putrid vegetable mould, more inclined to sand than to clay', was, as Arthur Young noted in 1797, 'of extraordinary fertility'.

It is unlikely that his family owned any pictures which might have influenced him greatly, and the first painting of real importance to him, Claude's *Hagar and the Angel*, he saw on a visit

(*Opposite*)
Golding Constable's Kitchen Garden, painted from a back window in his father's house in 1815, and *Spring Ploughing, East Bergholt*, of about 1816, showing the windmill where Constable had worked.

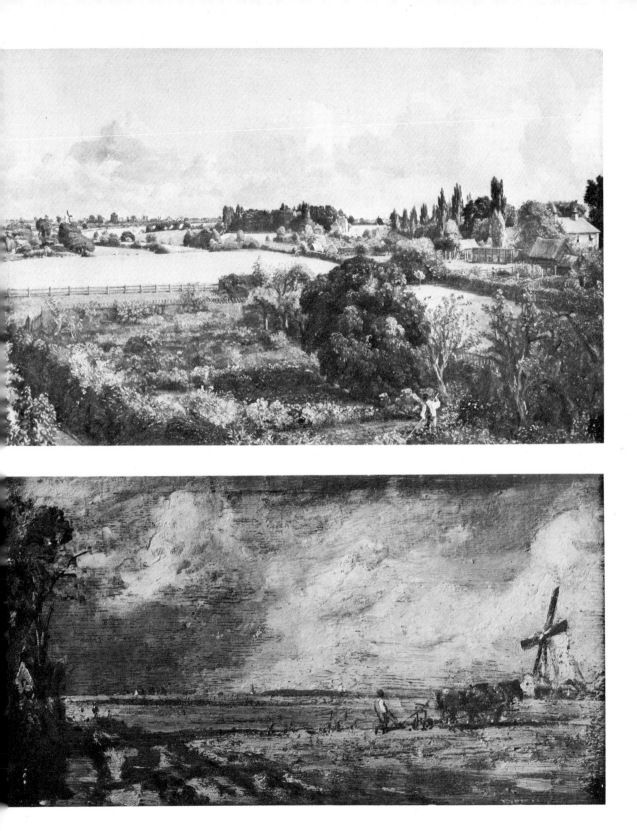

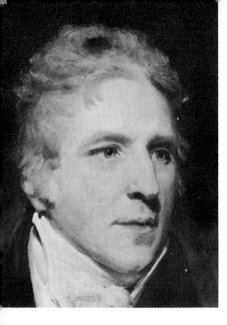

Sir George Beaumont (*above*, detail of the portrait by John Hoppner, RA) was an amateur painter and the patron and benefactor of Coleridge and Wordsworth as well as of Constable, to whom he gave valuable advice and encouragement over more than twenty-five years.

Hagar and the Angel by Claude Lorrain (1600–82) was first seen by Constable probably in 1795 when Sir George Beaumont (who took it with him everywhere) brought it to Dedham. Its composition shows striking similarities to that used by Constable in his *Dedham Vale* of 1802.

(*Opposite*)
Dedham Vale, painted from Langham in 1802, with the Stour meandering towards the sea in the distance. The view is now obscured by trees.

to its owner, Sir George Beaumont, whose mother lived in Dedham.

Sir George was a patron of the arts; and patrons were of course even more important then than now. Not only did they buy the work of living painters but they also allowed artists and interested people to see their collections if an appropriate introduction had been obtained. If you received an invitation you would probably be taken, in your patron's carriage, to look at his pictures at his house. With the banker John Julius Angerstein and the Marquis of Stafford, Sir George Beaumont was numbered among the most distinguished of patrons. He also painted, and though he possessed no conspicuously original artistic talent he produced more than two thousand paintings, which was prolific for a dilettante. It is hardly an exaggeration to say he was obsessed by pictures. The megalomaniac historical painter B. R. Haydon wrote of a visit to Beaumont's country seat at Coleorton in Leicestershire:

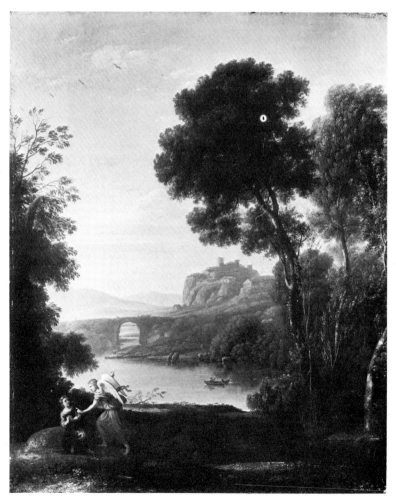

We dined with Claude and Rembrandt before us, breakfasted with the Rubens landscape, and did nothing, morning, noon or night, but think of painting, talk of painting, dream of painting, and wake to paint again.

So when the young John Constable, probably in 1795, showed Sir George at Dedham some copies he had made from Dorigny's engravings of Raphael's cartoons in pen and ink, the patron showed his mother's young neighbour his favourite painting by Claude Lorrain, *Hagar and the Angel*, and some watercolours by Girtin. (So attached was Sir George to the small Claude that he took it with him on his journeys in a specially made travelling box.) The meeting was to be of considerable consequence. Constable met a great patron; he also saw the Claude and the Girtins, and the work of the former was to exert a powerful influence on his artistic development.

John's father had by no means abandoned his ambitions for his son's business career. In 1796, John stayed with his mother's relations the Allens at Edmonton. The purpose of the stay was probably to enable John to seek out some means whereby he could further his career in the corn trade. But the more significant result was his meeting with J. T. 'Antiquity' Smith, a well-known character in artistic circles. Smith had been born, ten years before Constable, in a hackney coach between Seven Dials and Great Portland Street. He later wrote a biography of the sculptor Nollekens, *Nollekens and his Times*. (His father had been Nollekens' chief assistant.) He had considered becoming an actor and earning his living at mezzotint engraving. Eventually he took up teaching, spent some years compiling his *Antiquities of London and its Environs,* and later became Keeper of Prints at the British Museum. His chief talent was for gossip, and we can be fairly certain that the young Constable was captivated by the man who said that the seven great events of his life of which he could boast were:

I received a kiss when a boy from the beautiful Mrs Robinson; was patted on the head by Dr Johnson; have frequently held Sir Joshua Reynolds's spectacles; partook of a pint of porter with an elephant; saved Lady Hamilton from falling when the melancholy news arrived of Lord Nelson's death; three times conversed with King George the Third; and was shut up in a room with Mr Kean's lion.

Smith's conversation almost always began with: 'Sit down, and I'll tell ye the whole story.' Among other things, he told Constable:

Do not set about inventing figures for a landscape taken from nature; for you cannot remain an hour in any spot, however solitary, without the appearance of some living thing that will in all probability accord better with the scene and time of day than will any invention of your own.

Here, if he needed it, was proof to Constable of his own observations in the fields at home. Leslie recorded in his biography that

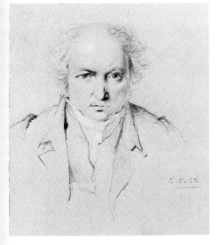

J.T. 'Antiquity' Smith, art teacher and *raconteur* (1766–1833), drawn by W. Brockedon in 1832.

'Often has Constable, in our walks together, taken occasion to point out, from what he saw, the good sense of Smith's advice.' Smith also introduced Constable to some of his friends, and so from these encounters with lesser artists of an antiquarian bent Constable gained an impression of what it was like to be a professional artist, and the impression was almost certainly a happy one.

He returned to Suffolk with two books recommended to him by Smith: Count Algarotti's *Essay on Painting*, published in England some twelve years previously, and Leonardo's *Treatise on Painting*. Later Constable asked Smith to send him the Swiss poet and painter Salomon Gessner's *New Idylles*, including the 'Letter to M. Fuslin on Landscape Painting'. When, next year, Constable bought a copy for himself he found he shared Gessner's preferences. Gessner, the 'Swiss Theocritus' and godfather to Henry Fuseli, looked first of all at nature and for its broad effects of mass in the works of Claude, Poussin and Waterlo; he also held in high regard the Scottish poet James Thomson's *Seasons*: 'How I pity the unfeeling landscape painter, whom the sublime pictures of Thomson cannot inspire.' Smith sent Constable a number of prints, including etchings by Waterlo which depicted landscapes which bore a general similarity to the countryside around the Suffolk–Essex border, and Constable set about copying them. Afterwards he used what he had learned and made some clumsy pen and ink studies of the local countryside itself.

There are some signs in 1797 that Constable's father was not entirely happy with his son's increasingly serious attitude towards art. R.B. Beckett, the editor of Constable's *Correspondence*, conjectures that John persuaded Smith to write to his parents with a good account of him. Mrs Constable replied saying that she looked forward to John's return 'with the hope that he will attend to business – by which means he will please his Father, and ensure his own respectability, comfort & accommodation'. The precise extent of his father's opposition is not known, but the fact that Beaumont and Smith both approved of John must have helped to overcome it.

Support of a different kind came from some of the local girls. Of the impression the aspiring artist made upon them we can gain an idea from the account of Ann Taylor, who was the daughter of a dissenting minister, and later wrote children's verse. She met John in 1799 and noted:

So finished a model of what is reckoned manly beauty I never met with as the young painter; while the report in the neighbourhood of his taste and excellence of character rendered him interesting in no small degree. There were, too, rumours afloat which conferred upon him something of the character of a hero in distress, for it was understood that his father greatly objected to his prosecution of painting as a profession, and wished

Cottages at East Bergholt, drawn in 1796, shortly after Constable met 'Antiquity' Smith.

John Constable at twenty-three, painted by his slightly disreputable youthful friend Ramsay Richard Reinagle.

John Fisher (uncle of Constable's lifelong friend of the same name), Rector of Langham and from 1803 Bishop of Salisbury, painted about 1812.

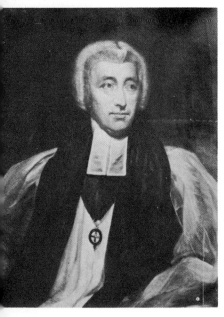

to confine him to the drudgery of his own business – that of a miller. To us this seemed unspeakably barbarous, though in Essex and Suffolk a miller was commonly a man of considerable property, and lived as Mr Constable did, in genteel style.

Ann Taylor was invited with her four sisters to visit John to look at his new paintings and the portrait just painted of him by Ramsay Richard Reinagle. (Even allowing for Reinagle's tendency to flatter the subjects of his portraits, the picture bears out the young Ann's opinions of John's good looks.) Ann also noticed that the artist's mother was 'a shrewd-looking, sensible woman'.

There we were, five girls, all 'come to see Mr John Constable's paintings', and as we were about to be shown up into his studio, she turned and said dryly, 'Well, young ladies, would you like to go up all together to my son, or one at a time?' I was simpleton enough to pause for a moment, in doubt, but we happily decided upon going up *en masse*.

In 1799 John won his father's permission to go up to London to study art, but before charting his progress in London we are bound to look at the background to two further friendships which were to be of paramount importance to him. The first of these was with the Fisher family.

R. B. Beckett calculates that the first meeting between John and Dr Fisher took place during the summer of 1798 when the Canon was staying at Dedham. Dr Fisher was then a Canon of Windsor. In 1790 he had become Rector of Langham in Essex, a post which pleasantly increased his income. He was celebrated locally as a friend of George III. Dr Fisher did not perform the Rector's duties; these were the responsibility of the Rev. Brooke Hurlock, who knew the Constable family well and introduced John to the Fishers. John Constable and Dr Fisher remained close friends for many years. It was with the Canon's nephew, also called John Fisher, that Constable was to form his closest friendship, one which was to be quite as valuable to him as Dunthorne's.

The second important friendship, with the Bicknells, was of greater importance, for it led, after a long and by no means easy courtship, to Constable's marriage to Maria Bicknell.

Maria was born in 1788, twelve years after John Constable. She was the daughter of Charles Bicknell (Solicitor to the Admiralty and Navy and to the Prince Regent) and his second wife, Mary. Mrs Bicknell was an invalid, and Maria was a regular visitor to her grandfather's house in East Bergholt. Her grandfather, the Rev. Durand Rhudde, was the forbidding Rector of East Bergholt and reputedly of substantial means. Relations between the Constables and the Rhuddes were never very friendly, but there was no reason for anyone to pay particular heed to the affection of the

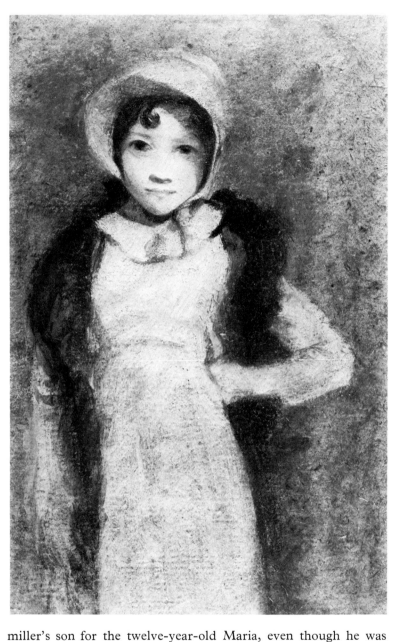

Maria Bicknell, aged about twelve, painted by John Constable *c.* 1800.

miller's son for the twelve-year-old Maria, even though he was twice her age. Ten years later matters were rather different.

In 1799, Constable took the coach from Ipswich to Charing Cross armed with a letter of introduction to Joseph Farington, a friend of Fisher's. Farington was a worldly-wise politician of art. As Graham Reynolds puts it well, he was 'a consummate example of those figures who exist in most developed artistic societies, the art politicians: in this case the 'Dictator' of the Royal Academy'. (Much later, on 8 April 1837, Constable's obituarist

wrote in the *Ipswich Journal*: 'He [Constable] has often been heard to remark that Farington was his *master*, but Nature was his *mistress*.') Constable told Farington that he knew Sir George Beaumont, and without fuss he was enrolled at the Royal Academy Schools.

The Academy Schools were not destined to charge Constable's imagination greatly. He applied himself energetically to his work, drew from the models and plaster casts, attended anatomy lessons, and, on his own, he copied from Claude, Poussin and Ruysdael. Even so his early days in London were not happy ones. His rural upbringing and devotion to the life of the Suffolk countryside made it the more difficult for him to enjoy the comparatively sophisticated company of his fellow students. An art student usually benefits as much from the influence of other students as from his teachers; Constable did not. Instead, he found solace in the discipline of work and was able to offer J. T. Smith some drawings for sale to bolster the small allowance he received from his father. He wrote home to Dunthorne: 'I paint by all the day-light we have, and that is little enough, less perhaps than you have by much. I sometimes however see the sky, but imagine to yourself how a purl must look through a burnt glass.' His homesickness is further evident in his confession to Dunthorne that:

Every fine day makes me long for a walk on the commons ... This fine weather almost makes me melancholy; it recalls so forcibly every scene we have visited and drawn together. I even love every stile and stump, and every lane in the village, so deep-rooted are early impressions.

A life class at the RA, about 1808, engraved by Pugin after Rowlandson.

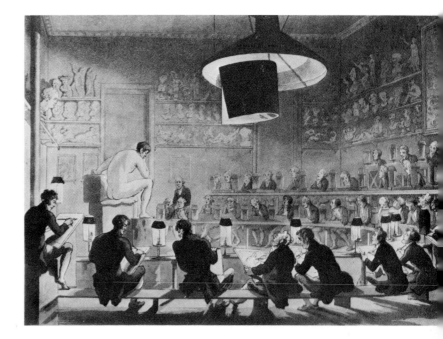

Here, Constable was perhaps recalling a recollection of Gainsborough by Thicknesse who recorded that Gainsborough told him:

there was not a Picturesque clump of Trees, nor even a single Tree of beauty, no, nor hedge row, stone, or post, at the Corner of the Lanes, for some miles around the place of his nativity, that he had not so perfectly in his *mind's eye*, that had he known he *could use* a pencil, he could have perfectly delineated.

Constable also heeded the advice of Benjamin West, the American-born President of the Royal Academy, who told him: 'Always remember, sir, that light and shadow never stand still.'

For a while Constable turned to Ramsay Richard Reinagle for friendship. Reinagle had inherited something of his father's abilities as a doubtful copier and 'improver' of old masters and his chief aim was to make a grand living from art as a businessman. Constable had his portrait painted by Reinagle (this was the portrait Ann Taylor went to see with her sisters) and even went into partnership with him to buy a Ruysdael for seventy pounds, which Constable copied. The relationship soured, and Constable wrote to Dunthorne saying it was 'difficult to find a man in London possessing even common honesty'; he implied that Reinagle was a man who forced his tongue 'to speak a language whose source is not in the heart'. He also told Dunthorne something about his lodgings:

I have got three rooms in a very comfortable house, No. 50, Rathbone Place. My large room has three windows in front. I shall make that my shop, having the light from the upper part of the middle window, and by that means I shall get my easel in a good situation.

Joseph Farington, R A (1747–1821), painted by James Nixon.

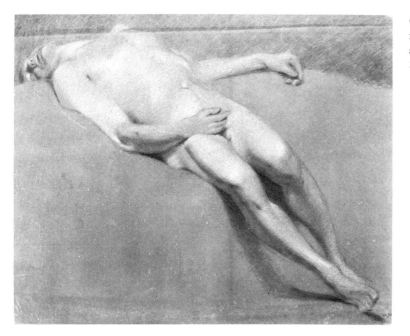

One of the many life drawings made by Constable about 1800, as a student in the Royal Academy Schools.

He condemned his 'old acquaintances in the art' and 'their cold trumpery stuff. The more canvas they cover, the more they discover their ignorance and total want of feeling'.

By March 1801 Reinagle was making disparaging remarks about Constable. Farington noted Constable's reaction in his *Diary*:

He said that he had been much discouraged by the remarks of Reinagle and others though he did not acknowledge their justness. He said in their criticisms they look only to the surface & not to the mind. The mechanism of painting is their delight. *Execution* is their chief aim.

In a letter of 1802 to Dunthorne he says, borrowing an idea from Sir Joshua Reynolds' *Discourses*, that he is not trying to make his 'performances look as if really *executed* by other men'.

The extent of Constable's contempt for the Reinagle family's activities is only thinly veiled in another of Farington's *Diary* entries. Constable told how Reinagle's sisters copied sections of Old Masters without the owner's permission and then touched up the watercolour they used with oil paint:

This, they said, their Father declared to be the only way of copying the pictures of Old Masters successfully. – They work very quickly, & said, 'Picture painted one day, – sold the next, – money spent the third.'

Not surprisingly, Constable steered clear of the Reinagle family from then on.

He was far more preoccupied with his own work, and perhaps it was in order to broaden his range of subject matter that he went to Derbyshire during August 1801. He stayed there with the Whalleys, relations of his sister Martha's husband. He brought back a number of pencil and sepia wash sketches which reveal more about his absorption of other artists' styles than the successful achievement of a personal vision.

His father remained unconvinced of John's good sense in selecting a career as artist. Yet, in spite of such misgivings as he had, he helped John find a studio opposite the family house in East Bergholt, and it was while John was in Suffolk in 1802 that he received a summons from Fisher to be introduced to General Harcourt, the first Governor of the Royal Military College at High Wycombe.

The General wanted a drawing master to teach in the junior department of the College, recently opened at Great Marlow. Constable went down to the interview with the General and stayed with the Fishers at Windsor; he passed it successfully, but West, Farington and Sir George Beaumont advised against accepting the post, and Constable turned it down. He still had to find a way of establishing his career.

He had no illusions about the difficulties of first asserting his view of naturalistic landscape in his paintings and then selling them.

Undated portrait of Constable, sometimes considered to be a self-portrait.

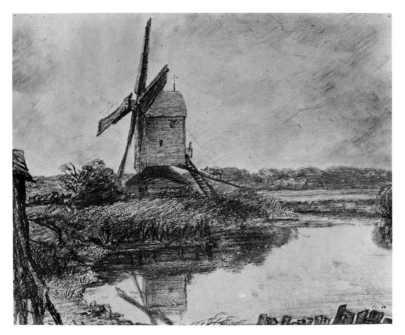

A Windmill, drawn by Constable on 3 October 1802. His brother Abram later said to C. R. Leslie: 'When I look at a mill painted by John, I see that it will *go round*, which is not always the case with those by other artists.'

In the first place painting landscape was regarded as inferior to painting subjects of a historical kind: the use of biblical stories or ancient myths as themes. Landscape painting was also considered less worthy than portraiture. This widespread view amongst artists and the interested public had been current for a considerable time. Thus, in *The Connoisseur* of 1719, Jonathan Richardson wrote:

A History, is preferable to a Landscape, Sea-piece, Animals, Fruit, Flowers, or any other Still-Life, pieces of Drollery, &c; the reason is, the latter Kinds may Please, and in proportion as they do so are Estimable ... but they cannot Improve the Mind, they excite no noble Sentiments.

Subsequently, Sir Joshua Reynolds allowed for some improvement in the status of landscape but by no means as much as would have suited Constable. It is true that a number of landscapes were exhibited at the Royal Academy in the annual exhibitions at the turn of the century. But even Turner felt it necessary to exhibit only his confrontations with the art of the past at the Academy during his early years. For example, in 1800 he exhibited *The Fifth Plague of Egypt* (which, in fact shows the seventh plague – Turner could not quite get his pedantry right), and this was a Poussinesque confection. Constable can hardly have been encouraged to think that his refusal to compromise with fashion would receive the approbation of the Academy's selection committee.

There were only a few other possibilities open to him: if he so wished he could seek work as a book illustrator of topographical subjects; or set himself up as a portraitist; or, like Crome and

Cotman, he could arrange to teach young ladies how to sketch. Otherwise, the professional opportunities were dismal. There were no facilities for the kind of one-man gallery exhibitions which artists may enjoy today, and no similar government patronage.

He chose the most difficult course: to persevere with his own version of landscape painting in spite of the odds against its achieving popular acceptance. There was, he felt, 'room enough for a natural painture', a style of painting free from the artificiality of history painting and the *formulae* of painting pictures derived from other pictures (the Picturesque). However strange the fact may seem to us, this was a revolutionary plan; and it was one which put Constable out on a limb from the ordinary run of popular and successful painters. It was to make his career a difficult one.

Apart from all these considerations, he still had a long way to go before achieving the kind of 'natural painture' he himself wanted. His gifts were very slow to emerge. Had he died in, let us say, 1810 at the age of 34, he would now be remembered as a minor artist. Turner, one year older than Constable, was elected an Associate of the Royal Academy in 1799 when he was only twenty-

four, twenty years before Constable. Turner had made numerous topographical drawings which were suitable for engraving and publication and his early works exhibited at the Academy fitted in with the acceptable styles. By 1810, Turner was in funds to the extent of £12,000 to £13,000, whereas the thirty-four-year-old Constable had to resort to the painting of his second rather miserable altarpiece, *Christ Blessing the Bread and Wine*, for Nayland Church in Suffolk. His aunt, Mrs Smith, promised to remember to make payment to him for this in her will. This she did ten years later and left him £400.

The portraits, altarpieces and commissioned copies he undertook were burdensome yet necessary. At the same time he experimented with different landscape subjects and slowly, deliberately and self-consciously extended his technical range. He made a brief sea-voyage around the south coast in 1803 and drew ships in the manner of Van de Velde; and he made another major attempt to broaden the scope of his art in 1806 in the Lake District.

The idea for the trip was that of his uncle, David Pike Watts. Mr Watts's charity was dispensed both in public and in private with conspicuous humility. His letters to John are chiefly distinguished by their pomposity. But his nephew was a willing victim of his uncle's philanthropic barrages and was by no means resentful of the advice and gifts. One of the latter, in the form of paid expenses for a trip to the Lakes, was especially useful.

He stayed there for some two months in the early autumn of 1806 with Mrs Harden at Brathay Hall near Windermere. Like the

(*Opposite*)
Nayland parish church, Suffolk, and the altarpiece painted by Constable in about 1809, *Christ Blessing the Bread and Wine*. His elder brother Golding may well have been the model for the face of Christ. After the service which marked its installation in the church, David Pike Watts studied the work for an hour and then returned to Bergholt, where he wrote a letter to his nephew containing twenty-five numbered points of criticism, most of which were friendly. Constable made no reply that has been recorded.

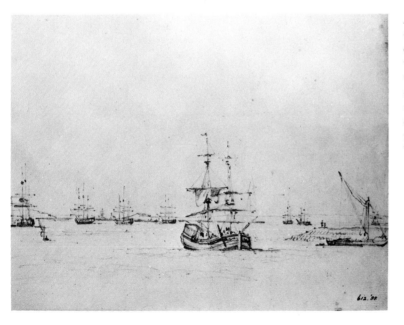

A Brig at Anchor and Other Shipping in the Thames, drawn by Constable in April 1803 when he made his only sea voyage, spending about a month on board the East Indiaman *Coutts*. This drawing, like many others he made of shipping at the time, shows the influence of Willem van de Velde.

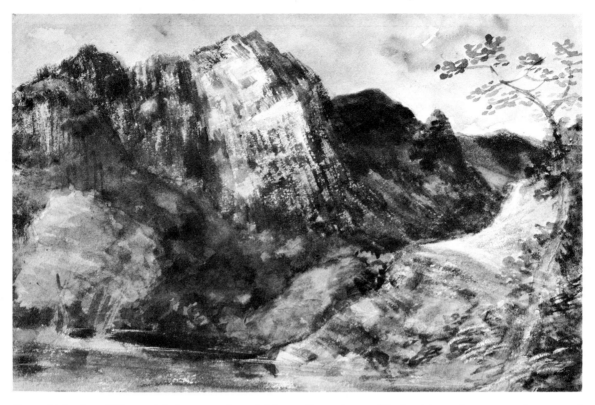

Constable's view of Borrowdale in 1806 – 'the effect exceeding terrific', he wrote on the back – showing Gate Crag and Castle Crag on the left.

results of his earlier trip to Derbyshire, the watercolours and drawings made in the Lake District reveal the influences of other artists; in this instance most especially Girtin and Cozens. They also contain an idiosyncrasy of his working methods – the noting of weather conditions and most striking features of the landscape, a useful working aid shown him by the amateur artist George Frost of Ipswich who shared Constable's affection and admiration for Gainsborough. On the back of a pencil and watercolour drawing of Borrowdale is Constable's inscription:

Borrowdale 4 Oct 1806 – Dark Autumnal day at noon – tone more blooming [?than] this ... the effect exceeding terrific – and much like the beautiful Gaspar I saw in Margaret St.

Even though he made some forty studies in the Lakes, Leslie says Constable found the landscape uncongenial:

I have heard him say that the solitude of mountains oppressed his spirits. His nature was peculiarly social and could not feel satisfied with scenery, however grand in itself, that did not abound in human associations. He required villages, churches, farmhouses, and cottages; and I believe it was as much from natural temperament as from early impressions that his first love, in landscape, was also his latest love.

Even so, Constable exhibited pictures he made in the Lake District and did not seek to suppress them. It was probably at the house of

Charles Lloyd near Brathay Hall that Constable met Wordsworth and Coleridge. A meeting between the three of them was described by Farington:

Constable remarked upon the high opinion Wordsworth entertains of himself. He told Constable that while he was going to Hawkshead school, his mind was often so possessed with images so lost in extraordinary conceptions, that he has held by a wall not knowing but he was part of it. – He also desired a lady, Mrs Lloyd, near Windermere when Constable was present to notice the singular formation of his skull. – Coleridge remarked that this was the effect of intense thinking. – I observed to Constable if so, he must have thought in his mother's womb.

Constable later told Fisher that he thought Coleridge's 'Ancient Mariner' 'the very best modern poem', but his taste was for a more traditional poetry. He showed consistent admiration for 'The Farmer's Boy' by Robert Bloomfield, quoted Goldsmith and Gray in letters, and described Cowper, his favourite, as the 'Poet of Religion and Nature'. The records of his meetings with Wordsworth are sketchy; his reaction to a reading of Wordsworth's *The Excursion* in 1823 was unenthusiastic, and it is perhaps dangerous to assume connections between poet and painter only on the grounds of some indetermined 'feel' for landscape.

It is now generally considered that 1809 was the year in which Constable completed his self-imposed apprenticeship. Earlier works such as *Dedham Vale* (1802) show what he had learned of composition from Sir George Beaumont's Claude, *Hagar and the Angel*. But by 1809 he had begun to show his skill in depicting the vitality of natural landscape, the textures of grass, plants and the liveliness of clouds and sunlight. He was also trying to give his landscapes a sense of drama by careful manipulation of light and shade, what he called the 'chiaroscuro of nature'. The idea is shown in his oil sketches and, once carried through, it gave rise to the sort of natural painting which distinguishes Constable's work from that of his stuffier contemporaries.

But he was still far from receiving general recognition and any sort of reputation as an established artist. At thirty-three the prospect of a prolonged professional struggle can hardly have been a pleasant one.

Perhaps the pattern of his life made the prospect a little easier to bear; this was divided into two. He used to spend the summer and early autumn at East Bergholt with his family; there he was able to observe and enjoy the countryside during its most beautiful seasons. Then he used to return to London to get his pictures ready for the exhibition at the Royal Academy in May. From time to time the pattern was broken by short stays with friends elsewhere. However, his struggle for professional recognition now became more pressing because he fell in love.

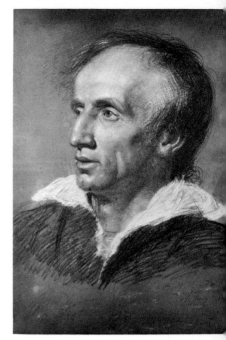

William Wordsworth, drawn by Benjamin Robert Haydon in 1818, at the age of forty-eight. Constable met him in the Lake District in 1806.

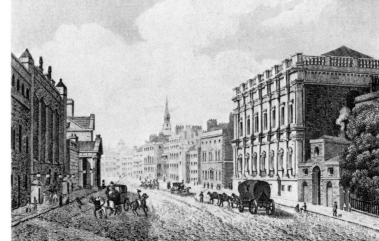

Whitehall, London, in 1810, looking towards the Admiralty, where Charles Bicknell acted as Solicitor; the Bicknells lived in nearby Spring Garden Terrace. Bicknell is seen below, in a detail of an undated portrait by Constable.

(*Opposite*)
Maria Bicknell at twenty-eight, painted by Constable shortly before she finally married him in 1816.

His courtship of Maria Bicknell began auspiciously enough. Mrs Constable found Maria both attractive and intelligent. John called on Maria's parents and was even invited to tea by Dr Rhudde, her grandfather. When the couple were apart the Bicknells offered to carry letters and parcels for them from East Bergholt to London and *vice versa*. In London, John would call at the Bicknells' house in Spring Garden Terrace, Whitehall. Sometimes Maria and her father, Charles Bicknell, called on John. There were no strong objections raised to the pair remaining friends; on the other hand, contemplation of marriage was another matter. After all, there were few signs, as John's father pointed out, that his son would be able to support himself, let alone a wife, by painting. To make matters more complicated still, Golding Constable and Dr Rhudde were prone to squabbling; and Dr Rhudde can hardly have approved of his granddaughter's suitor who was, apparently, unwilling to work for a living, and he was most likely also averse to John's friendship with John Dunthorne, who was an atheist.

Mrs Constable monitored various developments in the Rhudde household on her son's behalf. Early in 1811, for example, she informed John that the invalid Mrs Rhudde was starving herself because she believed 'the Bicknells were below, *poisoning* every thing she should eat – but hunger prevailed and she called out or rather made signs, for a pork chop or a mince pie'. The village gossips noted inconsistencies in Dr Rhudde's domestic arrangements; they observed he was using the services of a Mrs Everard as hostess at his dinner table, and this Mrs Everard, no one needed reminding, had a weakness for the clergy.

Ten days after Mrs Constable had sent this village intelligence to her son in London she thought up a plan. She suggested to

26

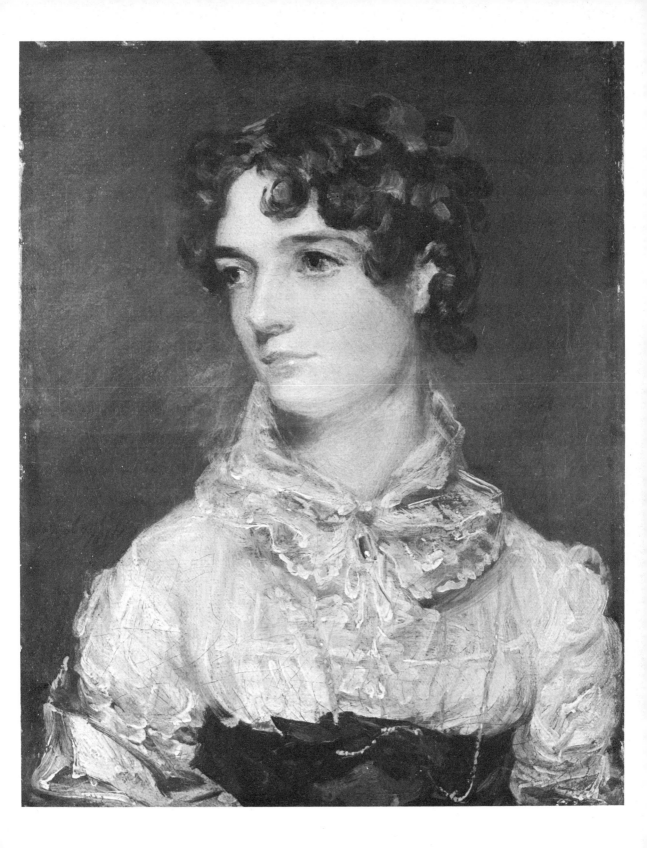

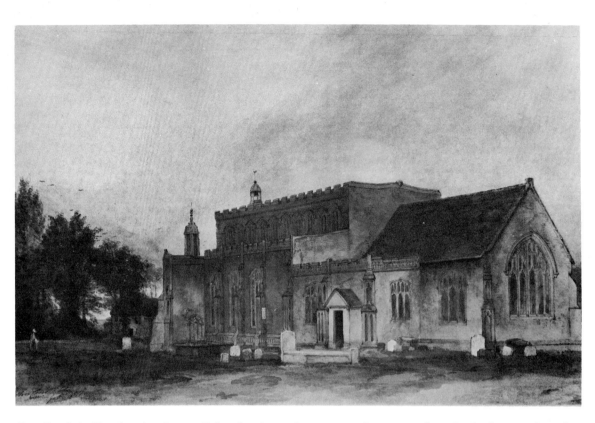

East Bergholt Church, painted from the south-east in February 1811; this is the watercolour that Mrs Constable presented to Dr Rhudde on her son's behalf.

John that he make a copy of a watercolour he had once given her of the church at East Bergholt. Consequently, Abram took the watercolour to London for John to copy with maternal instructions: 'draw its true likeness, and have it *neatly framed* and glazed, as a present from you to Dr Rhudde – it is what he so much wishes for. Take care of the copy, which I hold almost sacred'. She was confident that the gesture would soften the Rector's heart. Unfortunately, when the Rector eventually received the drawing he gained the impression it was the gift of Mrs Constable and not John. Even so, he later wrote to John with a bank note with instructions to use it for 'the Purchase of some little article by which you may be reminded of me, when I am no more'. (The money was used after the Rector's death in 1819 for the placing of a memorial tablet in East Bergholt church.)

Shortly afterwards ill-health affected both sides. Mrs Rhudde died, and at the funeral Mrs Constable noticed how ill Charles Bicknell looked. Mrs Bicknell was already an invalid, and now Durand Bicknell, her eldest son, was dying from tuberculosis. Furthermore, John's own health was showing marked deterioration; he was suffering, apparently, from depression. Even Sir George Beaumont noticed. Leslie records that, as a cure, Sir George proposed that John copy a landscape by Richard Wilson

at Sir George's house in Grosvenor Square entirely by memory. Constable was to look at the picture, memorize it, then return home and paint what he could remember – and so on until the picture was finished. The cure was not successful. David Pike Watts, his uncle, decided it was his turn to offer advice. He wrote to John on his thirty-fifth birthday:

I am sorry to see too visible Traits in your whole person, of an inward anxiety, which irritates your nervous system and in its effects doubtless deranges the digestions & secretions, vitiates the Blood, and undermines the Health.

Watts put John's state down to one 'predominant' cause – 'a deep Concern of the Heart and Affections'. And he suggested a connection between 'times of public calamity, when War distresses a Kingdom from without' (the Napoleonic Wars) and John's particular deprivation of 'the natural Affection of Love and the endearments of conjugal union'. Watts, of course, was always ready with personal advice for his nephew. It was understandable: only a few months before he had lost his last remaining son, Ensign Watts of the Coldstream Guards, at Barrosa; his daughter was about to leave home, and he too had once experienced an unhappy love affair; like his nephew, he was by no means a happy man. Even so, he overdid things by writing to John again, and this time about his paintings:

My opinion is, that cheerfulness is wanted in your landscapes; they are tinctured with a sombre darkness. If I may say so, the trees are not green, but black; the water is not lucid, but over-shadowed; an air of melancholy is cast over the scene, instead of hilarity.

Hilarity, in any sense, was the very last quality that Constable had in mind. There was at least comfort to be gained from an invitation to stay in Salisbury. Constable had known Dr Fisher, who was now Bishop, for some thirteen years; he had already paid frequent visits to the Seymour Street house where he was extremely popular and well-received. Mrs Fisher went so far as to comment to Farington that Constable reminded her of a young man from a painting by Raphael. If so, then Constable must have successfully disguised the pain of difficult courtship. In any event, the invitation to stay at the Palace in Salisbury in the autumn of 1811 must have been welcome.

The civilized and cultured Fishers were generous with their hospitality. They also introduced him to Sir Richard Colt Hoare, the banker and antiquary, who lived at Stourhead where the landscape gardens were at their best. Even though the weather was poor, Constable's spirits were temporarily revived. He noted that Sir Richard was 'no inconsiderable artist himself'. And he met

David Pike Watts, the artist's uncle, painted about 1806. He dispensed numerous gifts to John Constable: prints, books, money, even a flute. Above all, he provided his nephew with endless advice.

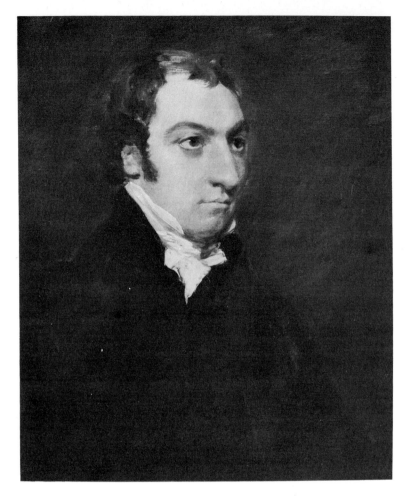

Archdeacon John Fisher in about 1816, five years after he first met Constable. Of him Constable was to write to Leslie on 4 September 1832: 'The closest intimacy had subsisted for many years between us – we loved each other and confided in each other entirely.'

Archdeacon William Coxe, for whom Constable had less admiration, noting rather sharply the Archdeacon's appetite for grand eating. He also visited Longford Castle and saw the Earl of Radnor's substantial collection of paintings. Even better, Bishop Fisher commissioned Constable to paint his portrait. (This drew the inevitable further flow of platitudes from Watts: 'You have attempted a great task and I wish you may acquire the general Vote of *Probatum est*.') But perhaps the most important meeting of all was with the Bishop's nephew, John.

Young John Fisher, Constable's junior by twelve years, had recently been ordained deacon. He was the eldest son of the Master of Charterhouse and the object of the Bishop's affection – the more so possibly because the Bishop's own only son, Edward, was mentally retarded.

John Fisher was gregarious, intelligent and wiser in the ways of the world than Constable, whose more rural and less sophisticated upbringing made his personality appear altogether more innocent

and perhaps more vulnerable than that of his friend. The differences were no obstacle to their friendship, and their shared love of the countryside cemented it. John Fisher's sympathy for Constable was to prove an abiding source of strength.

Constable returned to London and his preoccupation with Maria at once re-asserted itself. His calls at Spring Garden Terrace went unanswered, and so he wrote to her instead. 'Am I asking for that which is impossible when I request a few lines from you?' He could hardly call yet again at Spring Garden Terrace without appearing a little foolish. There then followed the long correspondence between the two lovers that lasted throughout the vicissitudes of their courtship until 1816. Although, as we would expect, it is far from being as literate as a story of Jane Austen's, it nevertheless conveys a similar sense of ordered passion.

Maria replied promptly yet carefully, realizing that her family would not welcome an affair between herself and an unsuccessful painter:

let me beg and entreat you to think of me no more but as one who will ever esteem you as a friend. I am confident it will hurt your feelings as much as it has done mine, but the sooner we accustom ourselves to what is inevitable the better.

At least he was aware that his feelings had been acknowledged. Her parents might object to a declaration of them – but she had not done so *herself*. While contemplating the matter John fell ill again, and used his indisposition to some effect in his letter to Maria of 29 October 1811:

Your letter found me recovering from the most severe indisposition I have ever experienced. I cannot say I have been quite well since I had last the happiness of seeing you – a gradual fever seems to have made some impression upon my constitution.

How am I to mention your letter – I have read it once only. Much indeed must I congratulate myself on having loved you ... it is impossible for me to think for a moment of relinquishing every hope of our future union, however unfavourable any prospects may be at present.

I feel some satisfaction in *knowing* that Mr Watts and my Father are willing to make every exertion in my favor. Do therefore soon let me hear from you again – and tell me that your own sentiments are not altered.

> Beleive me to be (dear Miss Bicknell)
> always most affectionately yours
> John Constable.

He did not wait for a reply and set off to visit Maria two days later. He was asked into the Bicknells' house and managed to gain permission from Maria's father to continue writing to her. Perhaps Mr Bicknell was confident that Maria would obey his wishes, and that if he allowed the correspondence to continue the affair would eventually cool off.

In the meantime Mrs Constable did not like to see her son cast down. She had been told by him of the developments and soon replied in a letter of 3 November 1811:

Your letter of the 31st ult. pleases me because it tells me you are, 'Far better'—but you cannot imagine how you have surprized & filled me with conjecture by saying this much—'I have been kindly received by the Bicknells, this morning, and my mind is in some measure quieted. I have Mr B.'s permission to write to Miss Bicknell which I have done this afternoon, October 31.'

Now my dear Son—what can this mean! and what may be augured from this! I pray it may be favourable for you & all—they are too good and too honourable to trifle with you, or your feelings—therefore I am inclined to hope for the best, and that all will end well, and to the mutual comfort of all. Perhaps I am too buoyant—what ought I to think or do—indeed I am in great straight. My maternal anxiety is almost overpowering to me.

Dedham Vale, Morning, seen from East Bergholt. This painting was exhibited at the Royal Academy in 1811; it was, according to C.R. Leslie, 'too unobtrusive for the exhibition, and Constable's art made no impression whatever on the public.'

Mr Bicknell had an eye on his daughter's future financial well-being; if she married John Constable, the prospects looked bleak. There was also the added worry that Dr Rhudde might show his disapproval and alter his will against Maria's interests. Maria informed John of her father's anxiety accordingly:

His only objection would be on the score of that necessary article Cash ... we should both of us be bad subjects for poverty, should we not? Even Painting would go on badly, it could not survive in domestic worry.

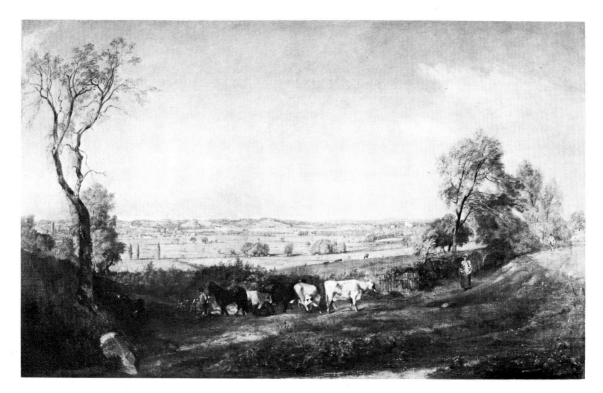

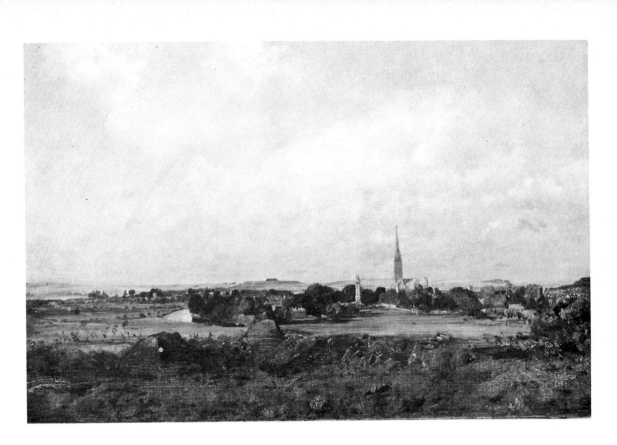

And she particularly requested him to take care of his health.

So he went to Epsom for a few days and stayed with his aunt, Mrs Gubbins. He then returned to London and moved his lodgings to 63 Charlotte Street, near to his friend Joseph Farington. To complete the restoration of his health he went to Bergholt, and when he returned once more to Charlotte Street to work on a general view of Salisbury he felt much better. Alas, Maria wrote to him only to advise against continuing the correspondence in case she upset him as well as her father. Even so, as she must have realized, to break off the correspondence would leave John heart-broken. As Maria was staying temporarily at Spring Grove, near Bewdley in Worcestershire, with her married stepsister Sarah Skey, John travelled to Spring Grove by coach and arrived on the door-step. Happily Sarah appreciated the situation well enough to allow John to stay a week, and his affair with Maria blossomed.

The Constable family viewed the matter with increasing concern. They were not of course opposed to Maria personally, but the idea of John's marrying with inadequate means of support caused his father to worry. He advised his son:

If my opinion were requested it would not be to give up your female ac-
quaintance in toto; but by all means to defer all thoughts of a connection

Salisbury, Morning, showing the cathedral spire from Harnham Hill, a result of Constable's first visit to Salisbury in 1811, when he met his lifelong friend John Fisher. The painting was exhibited at the Royal Academy in 1812 and achieved little notice. It is now in the Louvre.

until some removals have taken place, & your expectations more certainly known.

My further advice recommends a close application to your profession & to such parts as pay best.... Be of good cheer John; as in me you will find a parent & a sincere friend.

Charles Bicknell remained cordial; but Dr Rhudde was still a force to be reckoned with. As Mrs Constable put it in a letter to John: 'altho' he smiles and bows to us, yet something still *rankles* at his heart, which I trust will never burst out whilst I live; – I will at least be cautious to avoid it'. And she urged him to keep on painting to be ready for the summer exhibition at the Academy. 'With days lengthening, do secure your fame, – which will bring oil to your flame. You see my maternal energy – but I must not urge you *too* much.'

Rhudde obviously preoccupied the Constables, and most of all John and his mother, who shared her son's sense of the ridiculous. She revealed that the relationship between Rhudde and Mrs Everard was flourishing – if not behind the Rectory's curtains at any rate in front of them in the garden – and was neatly symbolized by the gardener:

A droll matter occurred at the Rectory last week – I mention it because I think it will make you smile – you will not repeat it I hope. Peck the gardener works there with Gilly, and he took it into his head last week to cut up the grass platt, you remember at the back of the house, and has raised two beds of moulds for flowers – just before the Doctor's study windows – & what shapes should his fancy have fixt on, but *two large hearts*.

'Truly ridiculous', as Mrs E. says. 'If he must make these places for flowers, why not ovals or squares – but two *monstrous* hearts.' I should not wonder if they were thought, synonymous *things*, and termed by the commonality, the Doctor's and Mrs E.'s. Methinks I have no objection to the Doctor's being touched by Cupid – as it may cause him to have a fellow feeling for *others* in the same situation.

Constable did not misunderstand the situation: he would be able to marry Maria only if he succeeded as a professional painter. The view was shared by his family, who encouraged him to paint portraits which would be more remunerative than landscapes. Bearing this in mind and taking heart from the increasingly affectionate tone of Maria's letters, Constable compromised and made some portraits whilst concentrating his mind most powerfully on landscape. His first visit to Salisbury, in 1811, resulted in the painting *View of Salisbury*, now in the Louvre. This was exhibited at the Academy in 1812, and when Constable happened to meet Benjamin West, President of the Royal Academy, in the street he asked West whether, in his view, he was pursuing his studies so as to lay 'the foundation of real excellence'.

'Sir,' West told him with characteristic gentleness and dignity, 'I consider you have achieved it.'

Constable had long since ceased to be a student and was now thirty-six years old; so in some respects West's compliment was double-edged.

He now fagged on at the reasonably profitable business of copying portraits. Catherine, Lady Heathcote, an MP's wife, commissioned a copy of John Hoppner's portrait of her as Hebe. She seems to have taken a strong liking to Constable. Twice she provided him with her ticket to the opera. 'She will not sit for me,' Constable told Maria Bicknell. 'Though she wants many alterations from the original – but I can have prints, drawings & miniatures, locks of hair &c &c without end.' Eventually it seems he grew tired of her attentions. He told Maria:

I see no end (if I stay) to my labours in Pall Mall – Lady Louisa [Lady Heathcote's mother] was quite distressed when I told her I must order my colors away. Lady H. is no better – she left some written orders on my table about her portrait, the most ridiculous imaginable.

It must have all been doubly trying: he wanted to hurry to Bergholt, and early in May 1812 Fisher issued him with an attractive invitation to visit Salisbury: 'We will rise with the sun, breakfast, & then out for the rest of the day – if we tire of drawing we can read or bathe & then home at nightfall to a *short* dinner.' He offered tea with friends or a walk in the Cathedral – 'or if the maggot so bites puzzle out a passage or two in Horace'. For the time being Constable stayed on in London to work, taking time off sometimes to walk with the deaf artist Thomas Stothard, a keen butterfly catcher who liked to pursue his hobby in Coombe Wood not far from Wimbledon.

In the middle of June he went down to Bergholt, and from there he wrote to Maria: 'From the window where I am writing I see all those sweet feilds where we have passed so many happy hours together.' He painted the portrait of William Godfrey, younger son of the local squire, wishing the while, as he told Maria, that she was with him. When Rhudde returned from a holiday at Cromer, Golding Constable informed him that his son was doing well with portrait commissions, but, as John told Maria: 'the Doctor would not hear my name'. Golding Constable offered John the use of a small cottage next to the mill at Dedham if he would stay at home instead of returning to London. But Constable turned the offer down and rejected the suggestions of his friends that it might, after all, be better to quit his profession altogether.

Early in November 1812 Constable returned to London, having called before he left on the Rector who 'seemed unusually gracious'. Unfortunately Maria was not in London but at the seaside in Bognor, and to add to his troubles a fire broke out in an upholsterer's below his lodgings in Charlotte Street on 10 November

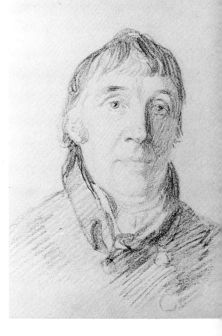

Thomas Stothard, RA (1755–1834), portrayed by John Flaxman. Some twenty years older than Constable, he was a kindred spirit who took Constable on long walks in the Surrey woods. Stothard's bothersome deafness provided no real barrier to the talks they had, invariably aided when they stopped for sandwiches by the flask of spirits Stothard carried with him.

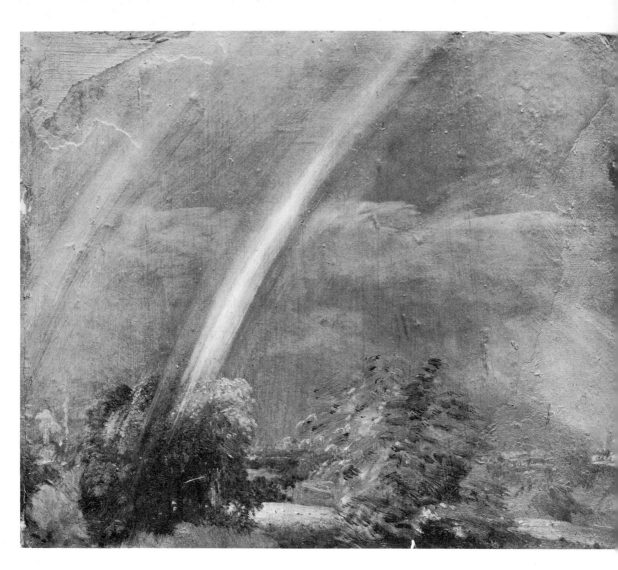

Landscape and Double Rainbow, painted by Constable on 28 July 1812 on a piece of torn paper stuck down on canvas. At the Executors' Sale on 16 May 1838, this painting and two others formed Lot 48, which C. R. Leslie bought in for the family for £5 5s.

at four in the morning. Constable managed to save his possessions, even though he was covered in a shower of glass while carrying Lady Heathcote's portrait by Hoppner to the safety of his friend Farington's house. When he returned to the fire Constable found one of the servants in great distress —

as all her fortune was in her garret – she particularly lamented her *pockets* which were under her pillows – there was no time to be lost, and I ran upstairs – and she was overjoyed to see me return with them through the smoke, for by this time we were almost all of us choaked with it, quite safe.

A few days later he received a letter from John Fisher thanking him for a picture Constable had sent. Fisher found the painting a little gloomy, but it was nevertheless much admired by Archdeacon

Coxe. 'It does not *sollicit attention –*' wrote Fisher. 'And this I think true of all your pictures & the real cause of your want of popularity.' Fisher advised him to look at Rubens and remedy the fault.

Maria returned to London, and the couple met shortly afterwards for a brief moment. John's portraits were proving to be something of a success, as his mother was quick to impress upon him:

You seem now my dear John in that situation that Fortune will place the Ball to your Toe, and I trust *you will not kick it from you*. You can now so greatly excell in Portraits, that I hope it will urge you on to pursue a path, so struck out to bring you Fame and Gain – by which you can alone maintain with respectability the Fair Object of your best & fondest hopes!!

New Year 1813: Constable completed a small portrait of Captain Western at Tattingstone Place near Bergholt, and it was well received. Bergholt was festive; there were balls and routs, but Constable did not join in the dancing. He hurried back to London to find that Maria had been ill, and immediately bombarded the Bicknell household with enquiries after the progress of her recovery. Mr Bicknell's rejoinder was to bar John from his house, and not until after the exhibition at the Royal Academy, when John exhibited two pictures, did John resume the correspondence with Maria. Even though West was complimentary, he found that 'Life indeed hangs very heavy on my hands –'. Then the British Institution presented an exhibition of works by Sir Joshua Reynolds, and a banquet was held to coincide with the opening. David Pike Watts provided Constable with a ticket, and the event impressed him no end, as he told Maria, in his letter of 13 May 1813:

It was a moment of exaltation and joy to me to see this honor and homage to my beloved pursuit – it was indeed the triumph of genius and painting.... The Regent left the table about ten and returned to the Gallery, which was now filled with Ladies – amongst them I saw Mrs Siddons, whose picture was there ('The Tragic Muse'). Lord Byron was pointed out to me – I was anxious for this sight of him – his poetry is of the most melancholy kind, but there is great ability.... Sir George Beaumont and the Bishop of Salisbury were very friendly, and I was a good while with them.

(He eventually changed his views on Byron. When the poet died in 1824 Constable told Fisher: 'The World is well rid of Lord Byron – but the deadly slime of his touch still remains.') John took Maria to see the Reynolds exhibition a few days later, and she was worried to see him looking 'so very far from well'.

Constable's paintings at the Academy were approved of by John Fisher: 'I only like one better & that is a picture of pictures – the Frost of Turner [*Frosty Morning*]. But then you need not repine at this decision of mine; you are a great man like Bounaparte & are only beat by a frost –'. Constable was generally occupied, not only

Mrs Siddons as the Tragic Muse, mezzotint after the portrait painted by Sir Joshua Reynolds, the presiding genius of the Royal Academy, in 1789.

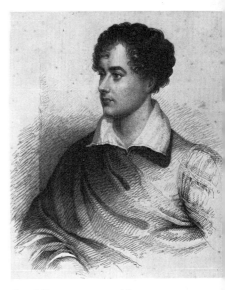

Lord Byron, engraved by R. Grave after James Holmes in 1811, when he was 23. His evil reputation, as well as his genius, made him an object of keen interest.

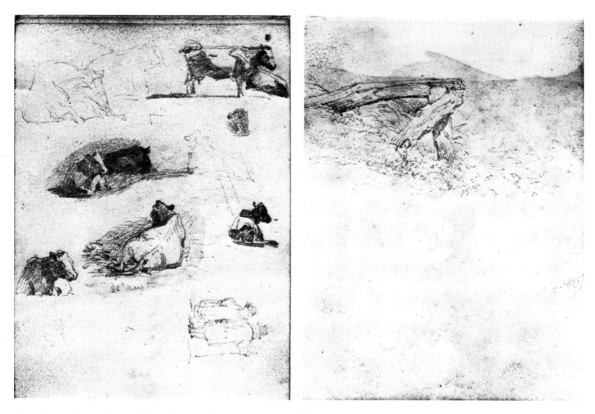

Four pages from Constable's 1813 sketchbook.

with portraits ('My price for a head is 15 guineas and I am tolerably expeditious when I can have fair play with my sitter') but with the redecoration of his Charlotte Street rooms. He had been living in Marylebone Street whilst his rooms were out of commission, and the solicitous Lady Heathcote offered her services as interior decoration advisor. He described the plan to Maria:

The paper will be a sort of salmon colour and the sofa & chairs crimson (by Lady Heathcote's advice). I think they will suit pictures but I am indifferent about show – though all insist upon it.... My front room where I paint shall be done with a sort of purple brown from the floor to the ceiling – not sparing even the doors or doorposts, for white is disagreeable to a painter's eyes, near pictures.

He also mentioned to Maria that he had dined at the Academy and sat opposite Turner whom he 'was a good deal entertained with.... I always expected to find him what I did – he is uncouth but has a wonderfull range of mind.' Constable was always to respect Turner, who was much the wealthier, more established artist and also the more fortunate in that he gained great confidence from the celebration of his work, whereas Constable had to resist growing anxious and depressed in the face of an indifferent public. The two men, whose paintings in themselves demonstrate their different artistic purposes, never became close friends, and

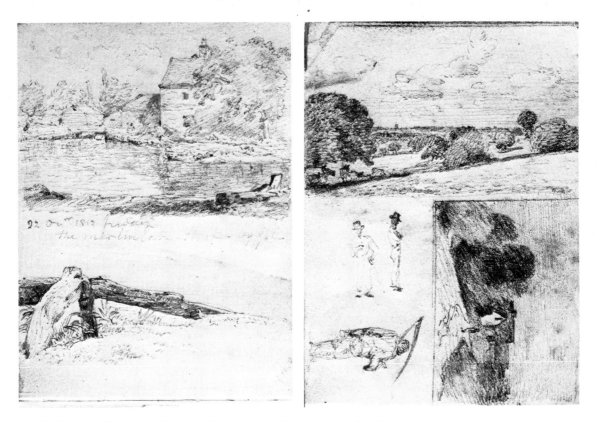

rarely if ever discussed their work together. In any case, both of them disliked talking about their paintings at length. 'Rummy thing, painting,' Turner would growl; and as Constable told Maria, 'I do not like to talk of what I am about in painting (I am such a conjuror).'

On 30 June Constable travelled to Bergholt and plunged into work; he filled a sketchbook of only $4\frac{3}{4}$ by $3\frac{1}{2}$ inches, bound in black leather and perfect for carrying about in the fields during the summer days which were some of the finest anyone remembered. Some ninety pages contain the drawings he made from 10 July to 22 October 1813: men at work with barges, barges drawn by horses, water-lilies, reeds, men ploughing, the Village Fair, open fields and the churches of the Constable Country. The small book is a perfect record of the scenes he loved and it is hardly surprising to find him writing of this prolific outburst of drawing and observing that he 'almost put [his] eyes out by that practice'.

The London winter of 1813 was a cold one, and on his return there Constable's spirits were very low indeed. To some extent his loneliness was relieved by John Dunthorne Junior, who stayed with him for a few weeks. Johnny was the son of his old boyhood friend, and he repaid the artist's hospitality by working as a studio

assistant. While the severe winter gripped London, Constable set to work on a view of Willy Lott's Cottage, a subject he was to use again frequently and in his most celebrated painting *The Hay Wain*. According to Leslie, Willy Lott had been born in the cottage and 'had passed more than eighty years without having spent four whole days from it'.

Constable had now been a practising artist for some fifteen years. He had of course sold a few portraits. But these small successes had always been the result of people he knew putting work in his way. So far no one he did not know had actually elected to buy one of his pictures, and this fact very largely contributed to his depression, for if it did not happen soon his chances of securing his bride must have seemed hopeless. The first stranger to buy one of his paintings was James Carpenter, a publisher and bookseller, whose business at 12 Old Bond Street specialized in books on art. On 13 April 1814 Farington noted in his diary:

Constable called to inform me that at the close of the British Institution Exhibition to make room for the works of Wilson, Hogarth and Gainsborough, he not having sold his picture of the *Lock scene* (landscape) was

Willy Lott's Cottage, at Flatford, today.

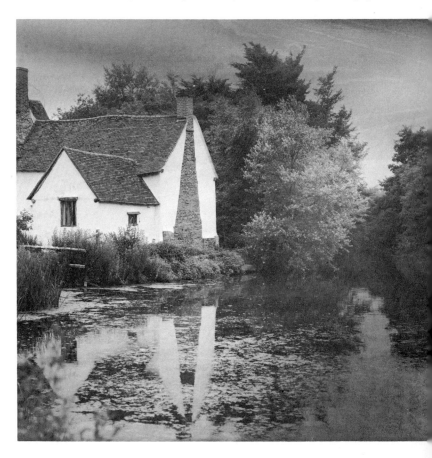

(*Opposite*)
Willy Lott's Cottage, painted in 1813–14. This little house, a favourite subject of Constable's, still stands by the Stour at Flatford, as the photograph on this page shows.

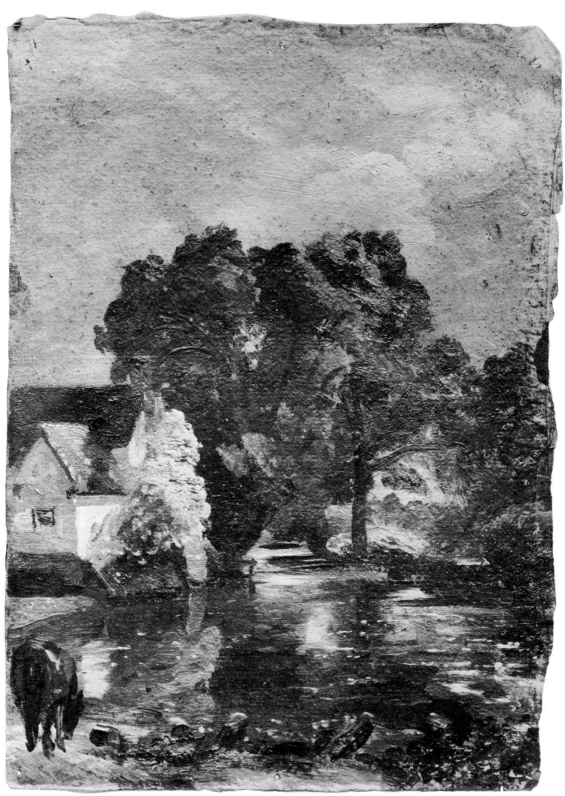

applied to by James Carpenter, the bookseller in Bond Street, who said he could not afford to pay the money he would willingly do, but he would give him 20 guineas in money, and books to a certain amount beyond that sum. Constable accepted the offer, & I told him I thought he did well.

Needless to say, Constable, who was a keen bibliophile, ever after took his custom to Carpenter. It is not now clear which painting it was that Carpenter bought; but, although Leslie maintained that Joseph Allnutt, a wine merchant who lived in some splendour near Clapham Common, was the first stranger to buy one of Constable's pictures, it would seem that Carpenter can fairly safely be said to have been the purchaser who so greatly strengthened Constable's flagging confidence.

The sale represented a measure of professional progress. This might have been speeded up had Constable been elected an Associate of the Royal Academy. He had been standing for election since 1810; each time he was rejected, for, as we have seen, pure landscape painting was far from generally acceptable. To have been elected would have been an obvious advantage: as his fellow artist William Collins, father of the novelist Wilkie Collins, said, the Academy was one place that did not regard artists as journeymen. Perhaps Constable's single-mindedness put people off. As Blake once noted, for the artist the question was 'not Whether a Man has Talents & Genius, But whether he is Passive & Polite & a

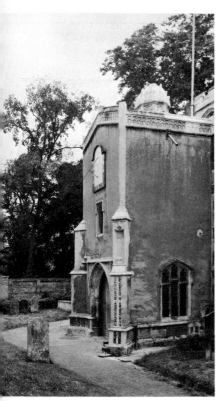

East Bergholt church today: the porch seen from a position similar to Constable's (*opposite*) – except that it is now necessary to stand on top of a grave, that of W. H. Travis, one of the two surgeons, father and son, who ministered to the ailments of the Constable family (and notably to John Constable's toothache).

Boat-building near Flatford Mill, a picture painted entirely in the open air, in 1815. David Lucas, the engraver, said that Constable 'was always informed of the time to leave off by the pillar of smoke ascending from a chimney in the distance that the fire was lighted for the preparation of supper on the labourers' return for the night'.

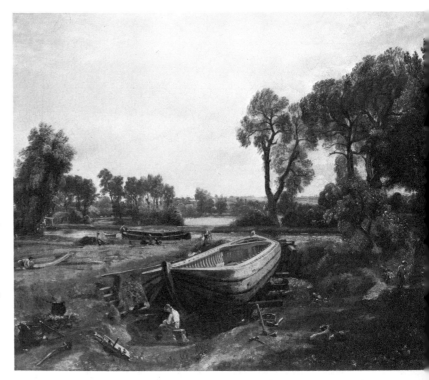

Virtuous Ass˙& obedient to Noblemen's Opinions in Art and Science. If he is, he is a Good Man. If Not, he must be starved.' Constable certainly needed the sort of recognition the Academy could provide; of course, he exhibited there and also at the British Institution which opened in Pall Mall in 1806. But the competition to get pictures hung was stiff; there was much bargaining, and selection was generally in the hands of reactionary connoisseurs. He was turned down as Associate of the Royal Academy at each election until 1819; and ten more years were to elapse after that until he was elected Royal Academician.

In July and October 1814 he filled another small sketchbook in Suffolk and wrote to Maria:

This charming season as you will guess occupies me entirely in the feilds and I beleive I have made some landscapes that are better than usual with me.... I beleive we can do nothing worse than indulge in an useless sensibility—but I can hardly tell you what I feel at the sight from this window where I am now writing of the feilds in which we have so often walked. A beautifull calm autumnal setting sun is glowing upon the gardens of the Rectory and on adjacent feilds where some of the happiest hours of my life were passed.

He also made a painting, *Boat-building near Flatford Mill* (exhibited 1815), entirely in the open air. The dry dock belonged to his father, and the picture is more finished than was usually the case—the result of his having seen the Claudes owned by the banker J. J. Angerstein. As Leslie noted:

This picture is a proof, that in landscape, what painters call warm colours are not necessary to produce a warm effect. It has indeed no positive colour, and there is much of grey and green in it; but such is its atmospheric truth, that the tremulous vibration of the heated air near the ground seems visible. This perfect work remained in his possession to the end of his life.

New Year 1815 brought a present of six shirts from his mother and news that his father's recent bad health had been rectified. Even better, Charles Bicknell made it known that John would not be a wholly unwelcome visitor at Spring Garden Terrace. At Bergholt Dr Rhudde was pleased to receive Mrs Constable's congratulations on his eighty-first birthday. But then while she was weeding her garden in the cold weather she felt giddy and fell down. She was carried into the house. At her request, prayers were said for her in East Bergholt church on Sunday 12 March 1815. Ann and Abram sent news of her failing health to John, and finally, on 14 March, Abram told John that the surgeon Mr Travis had suggested John should come to his mother's bedside. Mrs Constable's condition remained the same, and so John went back to London. But at the end of the month she died. Some weeks later Maria's mother died also. Constable wrote to Maria:

East Bergholt Church Porch, dated Saturday 17 September 1814.

Constable's visiting-card, and (on the back) a drawing of Wimbledon Park he made on a visit to Maria at Putney on 3 July 1815. (The I long remained interchangeable with J, especially in carved and engraved inscriptions.)

That we should both of us have lost our nearest friends (the nearest we can ever have upon Earth) within so short a time of each other is truly melancholy – and more than ever do I feel the loss of your society. Indeed I never felt the misfortune of our being apart more severely than at this moment, as I am convinced that we should be a mutual comfort to each other – .

Mr Bicknell took a cottage at Putney in the summer, and Constable was able to visit Maria there from time to time. He suggested a meeting for 3 July on Putney Bridge at a little before eleven in the morning, and on this occasion made a small drawing of Wimbledon Park on the back of his visiting card. On 6 July he left again for East Bergholt. In his letters to Maria from Bergholt, Constable seemed altogether calmer, and Maria was pleased to comment on this improved state of mind. Constable told her: 'I live almost wholly in the feilds and see nobody but the harvest men.'

In December, during the cold weather, Golding Constable was confined to his bedroom, and after a collapse the family realized he was dying. The state of his father's health caused Constable so much anxiety he could not work. But after Christmas, once he could see his father was resigned to death, he felt able to work again, and his father even joined him in drinking Maria's health on her birthday, 15 January 1816. Rhudde, for his part, showed sympathy towards the dying Golding Constable, but his attitude towards John was as obstinate as ever. The lover, meanwhile, continued to write, and John arranged to provide Maria with a puppy to replace her own dog, Frisk, who had died recently. Golding Constable held his own, and all seemed calm at East Bergholt until there arose an unexpected contretemps.

It seems that Maria's fourteen-year-old sister Catherine needed to be moved to a new school. Someone suggested that she attend the school being run by the lively Miss Taylor, sister to the Vicar of Dedham, in the house next to the Constables'. Miss Taylor had

recently commented to John that she was short of pupils, so John mentioned the present problem of Catherine's education. Unfortunately, Miss Taylor must have been struck with so much enthusiasm for this suggestion that she mentioned it to Dr Rhudde. That Constable should feel well enough accepted by the Bicknell family to discuss such a problem brought on the Rector's wild infuriation. And had not Constable been forbidden to visit Spring Garden Terrace – let alone see Maria? Senility getting the better of him, Dr Rhudde declared that he no longer considered Maria to be his granddaughter, and raged against her father for not telling him what had been going on. All of which prompted John to write to Maria on 18 February 1816:

It is sufficient for us to know that we have at no time done anything that is blamable, or to deserve the ill opinion of any one.

After this my dearest Maria I have nothing more to say – but that the sooner we are married the better and from this time I shall cease ever to hear any arguments of any sort from any quarter. We have been great fools not to have married long ago by which we might perhaps have stopped the mouths of all our enemies. . . .

Indeed, as a result perhaps of comments by Maria, he had even broken off relations with the atheistical elder Dunthorne, whose behaviour had made continued friendship inadvisable.

In May, John had to return to London to attend to his submissions to the Academy Exhibition. On 14 May, Golding Constable died peacefully sitting in his chair.

The death had long been expected. Golding's estate was divided equally among his children. Abram was to manage the family business and pay John some £200 a year. (On top of this he was already receiving £100 a year allowance.) So, given that he might make a further hundred annually from painting, he estimated he would have enough to support Maria as his wife. His mind was full of financial arrangements throughout the summer. On 29 July David Pike Watts died, but unfortunately left all his fortune to his

Mary, the wife of Constable's friend John Fisher, painted in about 1816.

daughter. Earlier in the month his great friend Fisher got married, which perhaps prompted Constable to tell Farington that he had decided to marry Maria in spite of what Rhudde might think or do.

In August he went to the Bicknells' cottage in Putney to visit Maria and presented her with the promised puppy, called Dash, from Ann Constable's kennels. Leslie tells that John sat beside Maria in the presence of her father and held her hand.

'Sir,' said Charles Bicknell, 'if you were the most approved of lovers, you could not take a greater liberty with my daughter.'

'And don't you know, sir,' Constable replied, 'that I am the most approved of lovers?'

John made up his mind to marry Maria in September, and on 27 August Fisher wrote from his parish of Osmington that he would hold himself 'ready and happy to marry' him. He continued:

There you see I have used no roundabout phrases; but said the thing at once in good plain English ... get you to your lady, & instead of blundering out long sentences about the 'hymeneal altar' &c; say that on Wednesday September 25th you are ready to marry her. If she replies, like a sensible woman as I suspect she is, well, John, here is my hand I am ready, all well & good. If she says; yes: but another day will be more convenient, let her name it; & I am at her service....

And now my dear fellow I have another point to settle. And that I may gain it, I shall put it in the shape of a request. It is that if you find upon your marriage that your purse is strong enough, to make a bit of detour, I shall reckon it a great pleasure if you & your bride will come & stay some time with me & my wife. That Lady joins with me in my request. The country here is wonderfully wild & sublime & well worth a painters visit. My house commands a singularly beautiful view: & you may study from my very windows. You shall [have] a plate of meat set by the side of your easel without your sitting down to dinner: we never see company: & I have brushes paints & canvass in abundance. My wife is quiet & silent & sits & reads without disturbing a soul & Mrs Constable may follow her example. Of an evening we will sit over an autumnal fireside read a sensible book perhaps a Sermon, & after prayers get us to bed at peace with ourselves & all the world....

Your visit will be a wonderful advantage to me – The inside of the Mail is both a rapid & a respectable conveyance & would bring you hither in 16 hours.

John sent the letter to Maria for her views and told her that his friends had persuaded him 'to try one more effort with the Doctor'. Maria wrote back from Putney to her 'dear John, you who have so long possessed my heart'. She wanted the wedding date decided, and she told John he should indeed write to the Rector even though there was 'not a ray of hope to be expected from him'. She said she felt she could not bring herself to read his answer. Her father had told her that the Rector's consent should be obtained. But the wedding was what mattered now; if a visit to the

Fishers afterwards would make John happy then she would of course go with him.

Then John wrote off to the Rector and again to Maria. This time, however, when he was virtually at the last fence, he decided to postpone the wedding so that he could complete *Flatford Mill*. Understandably, Maria was taken aback. After all this, her man persisted in putting painting before the 'hymeneal altar'. John apologized for his unkindness ('I have an anxious mind ...'). He did not want her to think marriage would get in the way of painting. She was coming to him '–not to oppose the habits & industry of a student but to solace them'. The main text of his letter set things aright–but, in a postscript, Constable once again put his foot in it. 'You talk about clothes,' he said, dismissively. 'I wish not to interfere–I always wear black myself & think you look well in it, but I should [say] the less we cumber ourselves in that way the better.' Maria handled him well in reply: 'Will you tell me how long your family remain in mourning, you cannot think that

Flatford Mill, completed in 1817; the lock and the mill are in the distance on the left.

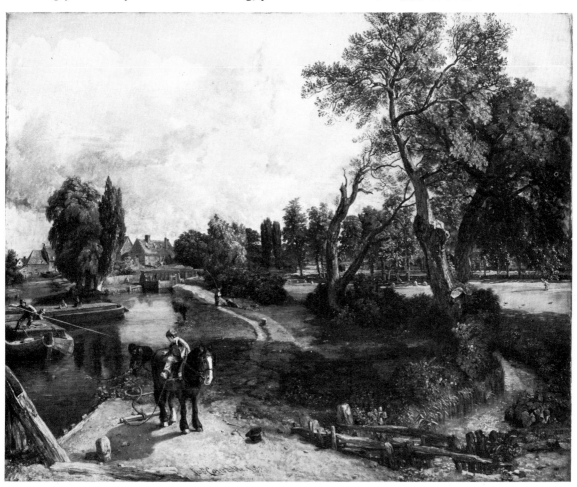

47

I would wear black for any other occasion. I dislike it very much.'
So John replied that she should not worry:

We shall meet in a few days, *to part no more for ever* – this thought must
be our sheet anchor in all the vicissitudes of this world.... I like black
best – do as you like – but I should think it advisable not to spend your
money in clothes, for we have it not to waste in plumb cake, or any
nonsense whatever.

At Bergholt, John's neighbours were already congratulating him.
The Rector did not reply to the letter. Instead, he passed John by
in his coach and bowed from on high. Rhudde's servant, seated
even higher, gave John an enormous grin. After further discussion
about the date, and arranging matters to coincide with Fisher's
visit to London, Maria wrote her last letter as a single woman:
'never mind, we shall soon finish with all these tiresome worrying
plans, or they *will drive me wild*, these few days are and will be
wretched'.

The couple pushed all opposition aside, and on Wednesday 2
October 1816 they were married by John Fisher in St Martin-in-
the-Fields. None of the Bicknells attended, and we do not know
whether any of the bridegroom's relations were present; Abram
might have been.

The honeymoon was a long and happy one. They first went to
Southampton and from there to Osmington where they joined the
Fishers. Constable painted Fisher's portrait and that of his wife
Mary. Maria and Mary became firm friends. Constable used
Fisher's kindly provided materials and painted from the beach at
Weymouth.

St Martin-in-the-Fields, the
Bicknells' London parish church,
just north of Charing Cross,
where John and Maria were
married in October 1816.

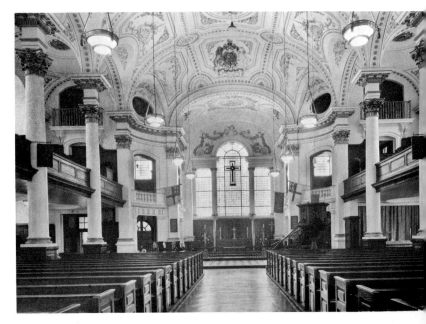

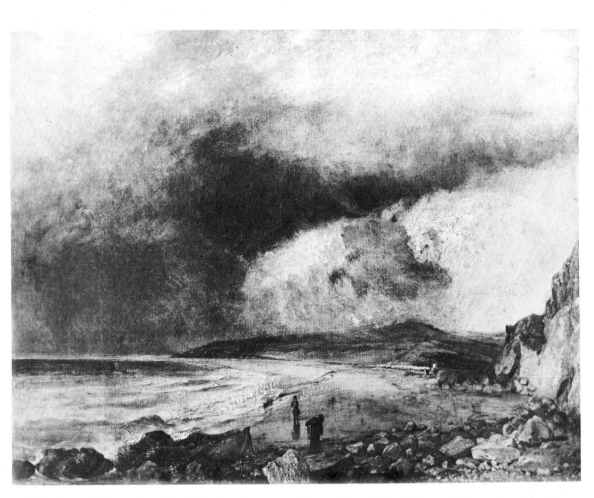

Weymouth Bay, painted in 1819, from a sketch Constable made on his honeymoon in Dorset in 1816.

The Constables arrived back in London on 9 December 1816 and spent their first Christmas together at 63 Charlotte Street. Charles Bicknell grew fond of his son-in-law, but Rhudde remained in a hostile mood. Ann Constable told John that the Rector had made his unfriendly intentions clear to Travis in the event of the newly married couple visiting East Bergholt: 'If they do, and call upon me,' Rhudde fumed, 'I will not see them.'

The Constables' neighbour, Farington, was generous with his hospitality and watched Constable busy at work preparing works for the 1817 exhibition at the Academy. Dr Rhudde's moods were never far from Constable's thoughts. There was a faint sign of improvement in April when Farington heard from Constable that the Rector had made provision in his will for any of Constable's future offspring. Without taking too cynical a view of this development, it may perhaps have been the result of Maria's miscarriage in February. Happily, late in April she was once again expecting a child, so Constable began to look around for more spacious lodgings. By June he had settled his choice on a house near the

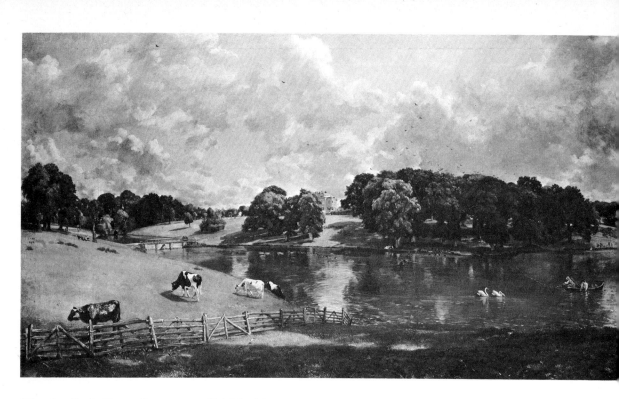

Wivenhoe Park, Essex, 1817, one of two paintings commissioned by General Francis Slater-Rebow. Wivenhoe Park is now the site of the University of Essex.

British Museum, 1 Keppel Street, which he agreed to take for seven years at a cost of about £100 a year. Fisher nicknamed the residence 'Ruysdael House', prompted by Constable's admiration for the Dutch artist, and Ruysdael House was to see the production of many of Constable's finest paintings as well as the start of his family. The latter occurred at 9 a.m. on 4 December 1817 with the arrival of John Charles Constable. The news was passed on to Rhudde by the local surgeon, Travis:

'What news?' asked Rhudde.

'You are a great-grandfather, Doctor,' Travis replied.

'You must now approach me with additional respect,' Rhudde declared, 'as I am a Patriarch.' And he muttered a few words about leaving 'it' something in his will.

Leslie records Constable's adoration for his children; John Charles 'might be seen almost as often in his arms as in those of his nurse, or even his mother. His fondness for children exceeded, indeed, that of any man I ever knew.'

Constable continued to paint portraits. But he still had not been successful in the elections at the Royal Academy. He visited East Bergholt, where the family's business arrangements were being sorted out and by 8 November 1818 the family house had been sold. Mary Constable and her brother Abram moved into a smaller residence at Flatford Mill. In the meantime John had written to the Rector in an attempt to set matters aright between the two of them

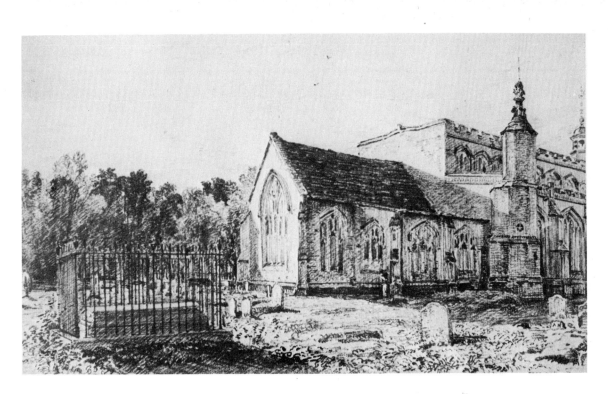

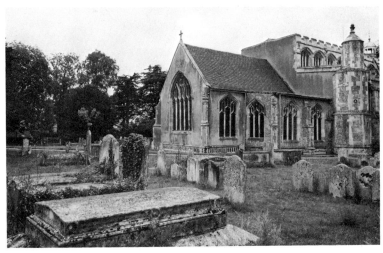

East Bergholt Church, with the tomb of the artist's parents on the left. Constable made the drawing on 28 October 1818, some two and a half years after his father died. The photograph below shows the church and the tomb in 1975.

and he succeeded at least in persuading, indirectly, the Rector to alter his will in favour of Maria. This he did after Christmas: Maria was to receive an equal share of his money when he died. This was just as well; for, according to Abram, 'The Doctor's memory gives way.'

If Constable was now to establish his reputation as a successful independent painter of landscape it was, by January 1819, essential for him to produce a large and major work. *Weymouth Bay* had

(Opposite)
The White Horse (1819) shows a
tow-horse being ferried across the
Stour at a point where the river
branches. It was the first of
Constable's grand tow-path
scenes. John Fisher, who bought
it at the 1819 RA exhibition,
contrasted it with a famous
painting by a president of the
RA, Benjamin West, *Death on
the Pale Horse* (below). West, who
kindly if a shade patronizingly
commended Constable's work in
1812, employs allegory and
artificiality, which Fisher
contrasts with the naturalism of
Constable.

(Below)
The Royal Academy Exhibition,
in about 1821, a cartoon by I.R.
and G. Cruikshank.

been criticized harshly in the *New Monthly Magazine* when it was
on view at the British Institution – 'a sketch of barren sand without
interest'. He concentrated his attentions on a canvas over four feet
high and six wide. The scene represents that point of the river
Stour at which the tow-path switches from the right bank to the
left bank between Flatford and Dedham. Here, at this stage in the
journey, it was necessary for the tow-horse to be ferried from one
bank to the other in the leading barge.

 This was a crucial bid for major recognition. It was to be his
only contribution to the Academy exhibition that year, and a very
great deal depended on it. The picture was finished early in
April and called *A Scene on the River Stour*. It is now popularly
known as *The White Horse*, and is in the Frick Collection, New
York. It was very well received. *The Literary Chronicle* declared:

What a grasp of everything beautiful in rural scenery! This young artist
[Constable was forty-two] is rising very fast in reputation, & we predict
that he will soon be at the very top of that line of art of which the present
picture forms so beautiful an ornament.

 At Bergholt, the Rector's mind was beginning to stray. He
would be found by his servants lost in thought in front of the
kitchen fire at six in the morning. Or he would wander about the
Rectory looking for the long-departed Mrs Rhudde. Abram wrote
asking John to visit Bergholt to see to family business, and when
he arrived, on 6 May, he learned that the Rector had died a few
hours before.

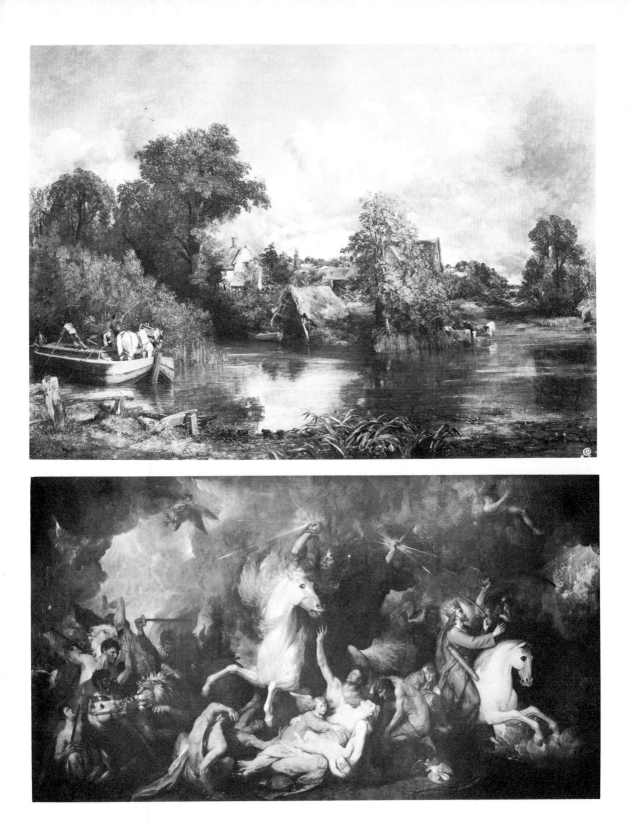

When Constable had presented Dr Rhudde with a drawing (see p. 28) in 1811, the Rector, refusing to be under an obligation, had sent him some money to buy a keepsake. The money was eventually spent on this tablet in East Bergholt church, carved by the son of Constable's friend Thomas Stothard.

Maria with John Charles and Minna, in about 1820.

The will provided the Constables with an additional £120 a year, which, with the capital from the sale of the family house in East Bergholt, improved matters considerably. Constable told Maria that he found it odd that the Rector should have died on his mother's birthday, since

the last letter she wrote was to congratulate him on his birthday.... But I will endeavour to forget those unhappy divisions & violent agitations which were real afflictions to both of them in this world, trusting that they are now in [a] scene where nothing but peace & love & joy can reign.

Some time later Abram wrote to John: 'We never hear the Doctor's name mention'd in any way whatever, *clean gone*.' On 19 July 1819 Maria had a daughter, Maria Louise or 'Minna', who was to become a particular favourite of her father's. Meanwhile the friendship with John Fisher was further cemented. Fisher had already written to Constable as follows:

My dear Constable

Will you have the goodness to tell me what price you put on your great picture now in the exhibition. We will call it if you please '*Life* and the pale Horse', in contradistinction to Mr West's painting [*Death on the Pale Horse*]. Did you not express a wish to have it on your easil again to subdue a few lights and cool your trees? I think you said so. Because the gentleman who meditates the purchase does not immediately want it.

Constable was not at once aware that Fisher himself wanted to buy the picture, and replied that the price was '100 Guineas exclusive of the frame'. When he eventually realized that Fisher did indeed want the picture, he proposed a lower price. However, Fisher stood by the original price and it was paid in instalments. On 20 August

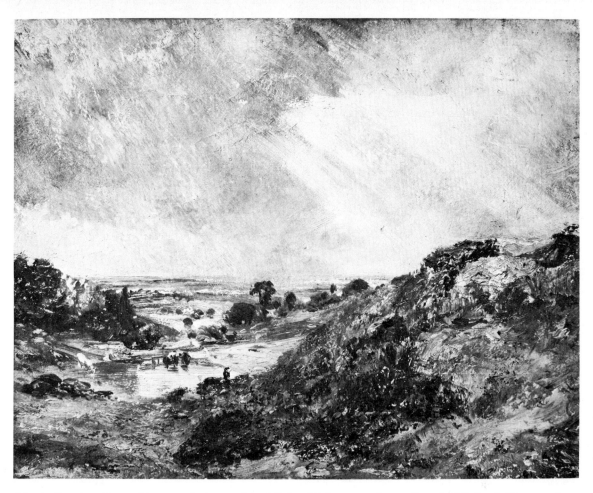

Maria Louise Constable was christened and John Fisher was her godfather.

During the same months Constable was encouraged by Farington to think that he might, at last, be successful in his wish to be elected an Associate of the Royal Academy. Before then he had to solve an additional problem. Maria had been unwell and it was thought wise to arrange a change of air. So Maria and her two children were dispatched to stay at Hampstead, near the Heath, where the air was clearer. Constable rented Albion Cottage on Upper Heath and there the family remained for a few months. During his visits Constable painted out of doors and added Hampstead to East Bergholt and Salisbury in his repertoire of subject matter.

The elections at the Academy took place on 1 November. Two places were contested – one for an engraver, one for a painter. Constable's friend C.R. Leslie was his chief opponent; in the decisive ballot Constable scored eight votes and Leslie five. Next day he wrote to Abram in a postscript:

Branch Hill Pond, Hampstead, painted in October 1819, some months after the Constables moved there, renting Albion Cottage, on Upper Heath, so that Maria might benefit from the clearer air.

I was last night by a large majority elected an *Associate* of the *Royal Academy*, therefore I am now J. Constable, A.R.A. for which I must humbly and sincerely thank them.

With some confidence restored by this long-delayed success he started work on a new large canvas entitled *Landscape* (now called *Stratford Mill*), which he had well in hand by April 1820. And Fisher wrote from Salisbury addressing his letter to 'John Constable Esqre ARA. &c &c &c'.

My dear Constable,

Constables 'White Horse' has arrived safe. It is hung on a level with the eye, the lower frame resting on the ogee: in a western side light, right for the light of the picture, opposite the fire place. It looks magnificently.

Stratford Mill was exhibited at the Royal Academy Exhibition in 1820; it shows the Stour at its bend about two miles upstream from Flatford Lock with a group of boys fishing, a theme which led Lucas to call the painting. *The Young Waltonians* when he published the mezzotint of the subject. Fisher bought the painting and made a gift of it to a Salisbury lawyer, J.P. Tinney, who had successfully undertaken a lawsuit on his behalf. Tinney was suitably impressed and went so far as to offer to buy Constable's next major work if no one else bought it when the exhibition ended. He also offered later on to commission two more paintings from Constable, leaving the artist a free choice of subject. The liberality of this arrangement had a different effect from that intended. Constable procrastinated; the longer he left the commissions the more difficult it became to face up to them. Constable's behaviour towards Tinney was uncharacteristic and

Stonehenge, drawn on 15 July 1820, when the Constables were staying with the Fishers in Salisbury.

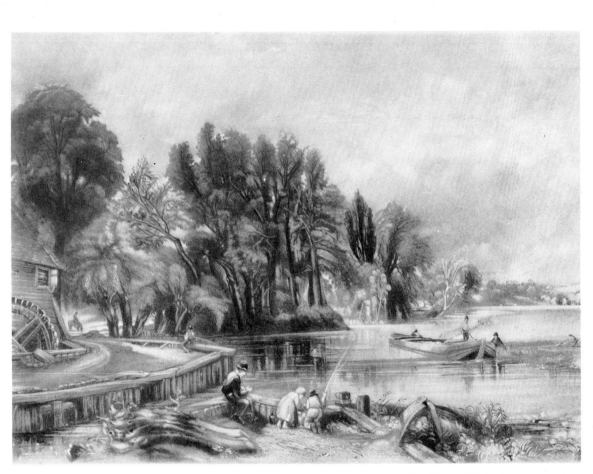

less than admirable; he said Tinney was obdurate, and, while admitting he was good-natured towards him, as indeed he was in the circumstances, Constable said ''tis ignorance only that disables him'. Something about Tinney irritated Constable; perhaps the artist knew he had let him down and the thought irked him. But Constable's continual borrowing of *Stratford Mill* from Tinney hints at a crisis of confidence. Matters were not to come to a head until 1824.

The Young Waltonians, mezzotint by David Lucas, published in 1840, after the painting *Stratford Mill* which was exhibited at the RA in 1820.

He was encouraged by Fisher to take Maria and the two children to Salisbury in July 1820. The wives were left with the children in the Cathedral Close while Fisher and Constable went on excursions to Old Sarum, Stonehenge, the New Forest and Gillingham. We can only imagine the conversation that passed between the two friends. Both were arch-Tories, and perhaps they dwelt in passing upon the follies of the Nonconformist churchmen. Leslie recorded that Constable's manner of talking

was perpetually disgressive, yet he never lost sight of the subject with which he set out, but would always return to it, though often through a long and circuitous path. His conversation might be compared to a dissected

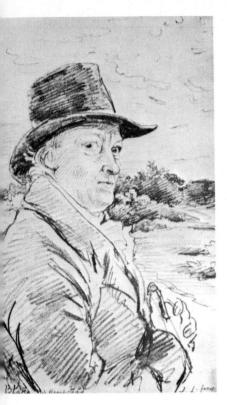

William Blake, drawn by John Linnell: artist, prophet, arch-foe of the Royal Academy.

map or picture, of which the parts, as seen separately, appear to have no connection, yet each is capable of being so placed as to form a complete whole.

If he saw a tree he delighted in, particularly an ash, he would respond, as Leslie put it, 'with an ecstasy of delight like that with which he would catch up a beautiful child in his arms'. That he relished the humorous and sharp rejoinder we can be sure. Fisher once asked him whether or not he liked a sermon he had just given. 'Very much, indeed, Fisher,' said Constable. 'I always did like that sermon.' If he delivered a reprimand, particularly to a servant or tradesman, it was invariably softened by a slight joke. To the milk-man: 'In future we shall be obliged if you will send us the milk and the water in separate cans.' Compliments he accepted with a certain detached caution. When Blake said of a drawing Constable had made (of an avenue of fir trees on Hampstead Heath): 'Why, this is not drawing, but inspiration', Constable said: 'I never knew it before; I meant it for drawing.'

Constable's joy in nature and his keen perception of it was shared by Fisher. The latter's account of a landscape he had seen is an almost perfect written counterpart of a landscape Constable might have chosen to paint himself – a testimony to Constable's influence on his friend:

A large black misty cloud hung to day over the sea & Portland. The Island could be but just discerned. The smoke of Weymouth was blown off towards Portland & was illuminated by the Western sun & releived by the dark cloud. As I rode home a complete arch of a rainbow came down to my very feet: I saw my dog running through it.

The Constables returned to London at the end of August 1820. John worked for a while on a painting of the new Waterloo Bridge, which had been opened on 17 June 1817 by the Prince Regent (see p. 96). But Farington advised him not to exhibit the painting and to produce a picture more in line with those major pictures he had previously exhibited at the Academy. So Constable started work on his third large painting: *Landscape: Noon*, or, as we now know it, *The Hay Wain*.

He began with a full-scale oil sketch now in the Victoria and Albert Museum, areas of which he left unfinished altogether, leaving the brown canvas to show through. This sketch served to demonstrate to Constable that the composition 'worked' well enough for him to embark upon the large and expensive undertaking of the final work for the Academy. Hence the hasty execution of the painting. 'Constable came to tea,' wrote Farington in his diary for 22 January 1821, '& reported progress made on a picture intended for the ensuing exhibition.' Perhaps this was the full-

Study of Ash Trees, made during the period 1817–19.

scale oil sketch. A few days later Abram wrote, commenting on Maria's pregnancy: 'I could almost wish your house was a little "swellded" as well as your good wife, or I am afraid you will soon be too thick.' Throughout February Constable worked on the picture in Keppel Street and wrote to Fisher:

My picture is getting on ... Beleive – my very dear Fisher – I should almost faint by the way when I am standing before my large canvasses was I not cheered and encouraged by your friendship and approbation. I now fear (for my family's sake) I shall never be a popular artist – a Gentlemen and Ladies painter – but I am spared making a fool of myself – and your hand stretched forth teaches me to value my own natural dignity of mind (if I may say so) above all things.

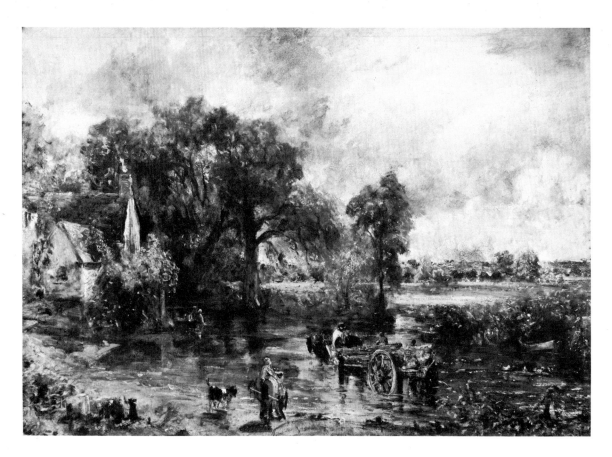

Full-scale study for *The Hay Wain*, 1821.

At this time Constable seems to have been struggling with the detail of the wain itself. He wanted to make sure that his Suffolk harvest wagon was accurate, as he had no sketch of his own to which he could refer. So he must have asked Abram to arrange for Johnny Dunthorne to sketch one for him; Abram wrote that he would send 'Dunthorne's outlines of a scrave or harvest wagon. I hope it will answer to desired end; he had a very cold job but the old Gentleman urged him forward saying he was sure you must want it as the time drew fast near.' The picture was far from complete.

Maria gave birth to a boy, John Golding Constable, at two in the morning on 29 March 1821, and on 1 April Constable wrote to Fisher that he was 'now releived of by far the greatest of my anxieties ... and all the rest of my (pictorial) anxieties are giving way to the length of the days and my own exertions – My picture goes to the Academy on the tenth ... (the window on the stairs must be taken out).'

The Hay Wain was exhibited in May at the Academy. It shows the view downstream across the mill race to Willy Lott's Cottage or Gibbeon's Farm where Lott lived until he died on 12 July 1849.

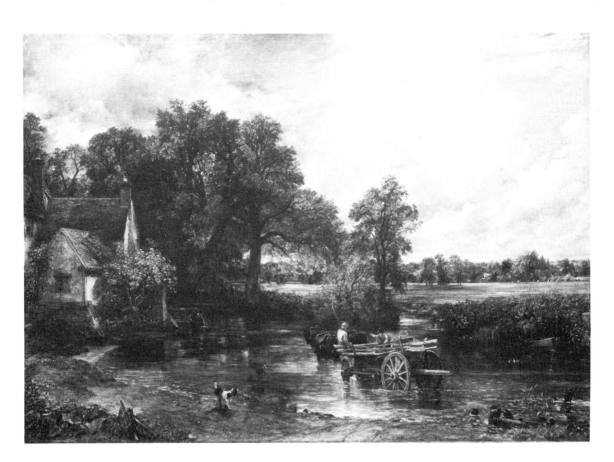

The view is now of course greatly changed, but it was probably taken by Constable from a small jetty or platform in front of Golding Constable's Flatford Mill. It must be a truthful enough depiction of the scene, although when Leslie visited it in 1840 he maintained that Constable had increased the width of the river.

No one bought *The Hay Wain*, though it received favourable critical comment, but it did have consequences which Constable could not have realized. It was singled out by two French visitors to England, Théodore Géricault, the painter, and Charles Nodier, the critic. Nodier later wrote: 'The palm of the exhibition belongs to a very large landscape by Constable with which the ancient or modern masters have very few masterpieces that could be put in opposition.'

Back in London Constable settled his family at 2 Lower Terrace, Hampstead. He worked with some difficulty on the fourth of his large paintings, *View of the Stour near Dedham*, now at the Huntington Library and Art Gallery, California. Some of the details in this he took from his 1814 sketchbook. He wrote to Fisher about his working surroundings:

The Hay Wain, showing Willy Lott's Cottage (see pp. 40–41). It is signed *John Constable pinx! London 1821*.

61

View of Lower Terrace,
Hampstead, the street in which
the Constables lived in 1821.

I have got a room at the glaziers down town as a workshop where is my
large picture – and at this little place I have small works going on – for
which purpose I have cleared a small shed in the garden, which held sand,
coals, mops & brooms & that is literally a coal hole, and have made it a work-
shop, & a place of refuge – when I am down from the house. I have done
a good deal of work here.

At the same time Constable was troubled by other problems.
Maria's sister Catherine was suffering from consumption – an afflic-
tion which had already resulted in her brother Samuel's death; and
then, on 30 December 1821, Joseph Farington died. Constable
was now without his skilled adviser in the theatre of art politics.
The sadness he felt at Farington's death was compounded with
other concerns: Fisher remained his only significant patron; he had
spent a great deal of time on *View on the Stour near Dedham* (he
preferred to call it *The Bridge*); to keep on the second house at
Hampstead was costly.

In February he failed to gain election as a Royal Academician.
The places went to Cook and Daniell, two minor artists, which
must have confirmed Constable's view that without Farington as
supporter and with Lawrence as President of the RA, the battle
to achieve promotion would be long and difficult. A few weeks
earlier Constable had dispatched *The Hay Wain* to the British
Gallery. Here, priced at 150 guineas, it was seen by John
Arrowsmith, in spite of his name a French picture dealer, who
carried on his business in Paris. Arrowsmith saw Constable at
Keppel Street and offered £70. Constable recognized that if the

picture were to be seen in France it might assist his reputation (as it eventually did); but he turned the offer down 'though I want the money dreadfully'. At the Academy *The Bridge* was received happily enough.

Since Farington's death his house at 35 Charlotte Street had been unoccupied, and as it offered space which Constable and his family needed he decided to take it on. The move to Farington's old house went well enough, some time after the birth of Constable's fourth child, Isabel. But Constable left Keppel Street with some regret. There, as he told Fisher, he had passed 'the 5 happiest and most interesting years' of his life, even though the family had been like 'bottled wasps upon a southern wall.' The only hitch in the move was the discovery that a house opposite Farington's was being used as a brothel. Constable took out a legal action against two of the brothel-keepers to get them moved on, and he was principal witness when the case was heard. After courtroom wrangles one of the women 'suffered judgment to go by confession, & [we] have agreed to pay all the expences, about 30 £. The inmates have long since fled.'

View on the Stour near Dedham, painted in 1822, with Flatford Bridge.

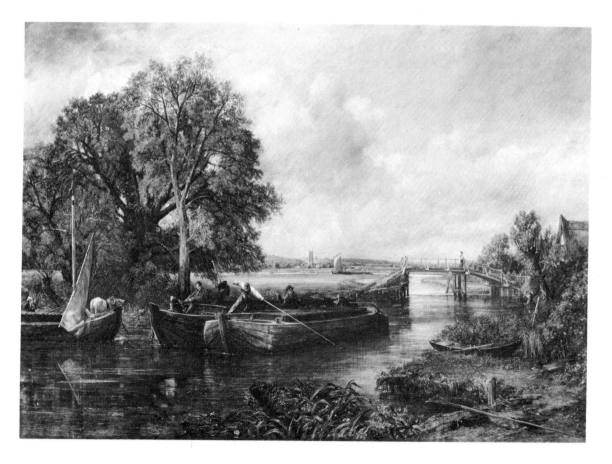

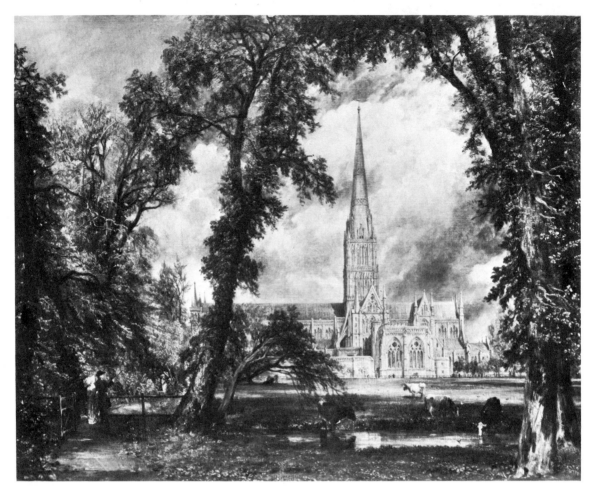

Salisbury Cathedral from the Bishop's Grounds, painted in 1823 for the Bishop, John Fisher the elder, who was unhappy with the clouds and would have preferred a blue sky. Constable painted a brighter version in 1826, but the Bishop did not live to receive it. Other versions include one painted as a wedding present for Elizabeth Fisher, the Bishop's daughter. The Bishop and his wife are on the left.

The new residence was damp and Constable discovered that a hollow wall in his painting room was constructed directly over the cesspit. Much work had to be done to make the house habitable. Not surprisingly perhaps, at Christmas, the whole family fell ill. But at least they had settled in comfortably enough and were getting on well with their immediate neighbours, Mr Prior and Mr Blatch, who developed a fondness for Constable's cats.

Ill-health and worry affected his work, particularly that required to complete *The Lock*, his next large painting. But he also had two commissions in hand from Fisher's uncle, the Bishop of Salisbury, one of which was *Salisbury Cathedral from the Bishop's Grounds*.

Once more, in February 1823, he was not elected Royal Academician. This honour went to, of all people, Ramsay Richard Reinagle – in Constable's words 'the most weak and undesirable artist on the list'.

The Lock was not ready for the Academy, so Constable submitted *Salisbury Cathedral*, which apparently prompted Fuseli's

remark recorded by Leslie: 'I like de landscapes of Constable; he is always picturesque, of a fine colour, and de lights always in de right places; but he makes me call for my greatcoat and umbrella.'

The fine summer raised Constable's spirits, and he finished commissions for Fisher which prompted him to tell the artist: 'Where *real* business is to be done you are the most energetic and punctual of men: in smaller matters, such as putting on your breeches, you are apt to lose time in deciding which leg shall go in first.' Fisher enclosed some money and said he wished he could afford to buy 'your "wain"', but he couldn't raise the money.

Just before autumn in 1823 Constable went to Salisbury and spent another idyllic few weeks with his friend and family.

In October he went to Coleorton in Leicestershire to stay with Sir George and Lady Beaumont. He sketched during the day with Sir George; in the evenings he would look through portfolios of drawings while Sir George read a play aloud, and was able to examine Sir George's Claudes at leisure. He wrote lovingly to Maria, repeatedly asking her to make sure the children (his 'dear little fishes') kept out of his 'nasty painting room'. A ball was held to celebrate Sir George's sixty-ninth birthday and fiftieth wedding anniversary. But Constable told Maria: 'I was lulled to sleep with a fiddle'.

In Charlotte Street Maria received visitors, notably two of Constable's admirers 'that great bore Peter Cox ... & Mr Judkin another of your loungers'. Judkin was a fanatical admirer of Constable's, and however dreary he might have been Constable would never show him the door. So Maria put up with his visits.

John Charles and Minna Constable playing in the nursery in about 1822. The sketch is inscribed by their father: 'all this is entirely his own invention – little mite inside'.

all this is entirely his own invention – little mite inside

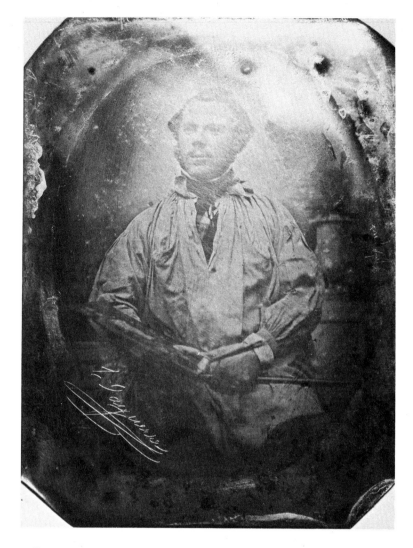

John Arrowsmith, the Paris dealer who promoted Constable's work, and with whom Constable had a memorable row in 1825. He was brother-in-law to the pioneer photographer L.-J.-M. Daguerre, who took this daguerreotype of him.

Constable stayed with the Beaumonts at Coleorton Hall until 28 November. This was the longest time he had ever spent away from his family, and though he returned renewed in spirit he was at once 'quite disabled' by severe toothache. Sir George wrote suggesting he take some exercise, but Leslie tells us that Constable's walks were always interrupted by something catching his attention and his pace only quickened when he was late for an appointment. The prospects for 1824 can hardly have seemed happy; but they were to be more favourable than he could have expected.

Arrowsmith, the dealer already mentioned, had an English name but spoke the language haltingly and with a heavy French accent. He is thought to have run a restaurant in the Rue Saint-Marc in Paris where a room was known as the 'Salon Constable'. It was

also known that he was brother-in-law to L.-J.-M. Daguerre, whose Diorama Constable had enjoyed seeing in 1823 in Regent's Park.

Early in 1824 Arrowsmith came to London again to try and buy *The Hay Wain*, which he seemed to be planning to have included in the autumn Salon. Arrowsmith may have heard talk of Constable from gossip put about by Géricault (who had probably talked to Delacroix about the picture), Nodier and perhaps another French-man, Amédée Pichot. News of the picture Arrowsmith called the 'Vain' had spread. Constable sought Fisher's advice on the offer Arrowsmith now made for both *The Hay Wain* and *The Bridge*. Fisher said that 'the stupid English public' would think more of Constable if the French made his works national property (as Arrowsmith had implied that they would). So a deal was arranged, and Constable accepted £250 for the pair and threw in a sketch, of *Yarmouth*, for good measure. Then *The Lock* was shown at the Academy and was bought by James Morrison, the price asked being 150 guineas with the frame. At the same time Arrowsmith sent his money over. Constable now had £400 in the bank, and he and Fisher regarded the French with rather less acrimony than before. Fisher now described the unappreciative English as 'boobies', and his lifelong dislike of the French, like Constable's, was forgotten now that they had declared their enthusiasm and offered payment into the bargain. 'Here I am,' Constable told Fisher, '& I must now "take heed where I stand."'

The sale of *The Lock* and French munificence were propitious; at last, at the age of almost fifty, it looked to Constable as though he might achieve financial independence as an artist. It is therefore particularly tragic that the first signs of his wife's fatal illness began at this time to declare themselves. Exactly what the matter was Constable never described in his letters; understandably no doubt, for the ravages of pulmonary tuberculosis had already taken their toll on Maria's family and the reality must have been intolerable to confront. Maria's mother had wasted away similarly before her death; her doctor, the able gynaecologist Dr Robert Gooch (also consumptive), can hardly have been unaware of the symptoms.

Brighton was chosen as the place for Maria's recuperation. In May 1824 mother and children travelled down with Ellen, the family maid, and the nurse, Mrs Roberts, to a house pleasantly situated near the beach. This was a fashionable place to con-valesce. The Prince Regent had already tried out sea-bathing in 1783, when, at the age of twenty-one his neck glands bothered him. Constable described Brighton to Fisher in a passage even more vivid than his paintings of the place:

From 1824 onwards, the family spent much time at Brighton for the sake of Maria's health. In a letter Constable vividly described the scene on the beach (*above*), which in his *Brighton: Marine Parade and Chain Pier*, 1824 (*opposite, above*) turns into the scene of natural rather than merely human events. *Colliers off Brighton Beach* (*opposite, below*) was sent to Fisher on 5 January 1825 with this inscription on the back: '3d tide receding left the beach wet – Head of the Chain Pier Beach Brighton July 19 Evg., 1824 My dear Maria's [Minna's] Birthday Your Goddaughter – Very lovely Evening – looking Eastward – cliffs & light off a dark grey effect – background – very white and golden light.'

Brighton is the receptacle of the fashion and offscouring of London. The magnificence of the sea, and its (to use your own beautifull expression) everlasting voice, is drowned by the din & lost in the tumult of stage coaches – gigs – 'flies' &c. – and the beach is only Piccadilly (that part of it where we dined) by the sea-side. Ladies dressed & *undressed* – gentlemen in morning gowns & slippers on, or without them altogether about *knee deep* in the breakers – footmen – children – nursery maids, dogs, boys, fishermen – *preventive service men* (with hangers & pistols), rotten fish & those hideous amphibious animals the old bathing women, whose language both in oaths & voice resembles men – all are mixed up together in endless & indecent confusion. The genteeler part, the marine parade, is still more unnatural – with its trimmed and neat appearance & the dandy jetty or chain pier, with its long & elegant strides into the sea a full $\frac{1}{4}$ of a mile ... In short there is nothing here for a painter but the breakers – & sky – which have been lovely indeed and always varying.

He settled his family in and returned to Charlotte Street.

It was probably Maria who encouraged him to keep a journal so that she could be kept informed about his own health. This was always liable to suffer, particularly in spring when he was at work on paintings for the RA. He was troubled by neuralgia (later, severely, by rheumatism), and rarely bothered to eat at regular times. (Lunch, usually his main meal of the day, was often replaced by an orange eaten while working.) The best maid had gone down to Brighton, leaving Sarah, the under-maid, behind in Charlotte Street. The absence of Maria and the children must have increased Constable's tendency to nervous depressions. Fortunately he took the precaution of asking Johnny Dunthorne, now twenty-six, to

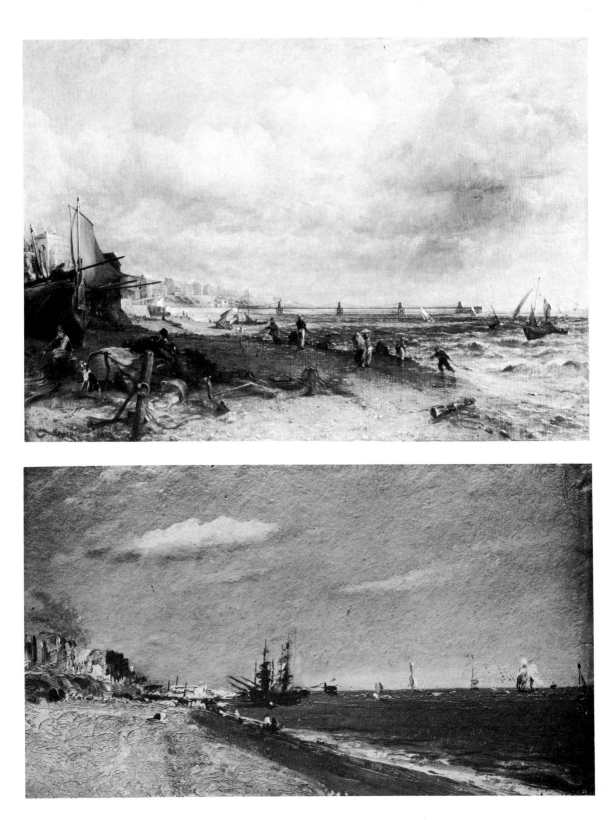

John Dunthorne the younger, an undated self-portrait.

stay with him in Charlotte Street. Further company was provided by the cats (Mrs Hampstead and Billy), the hens in the garden at the back, and the pigeons for which Constable provided a water-dish on the sill of the back drawing-room window.

Aside from painting there were visits to the studios of other artists living in the area. Constable, with his dislike for well-off artists, particularly portrait painters, tended to mix with those who were less successful. He was especially loyal to the deaf-and-dumb painter Samuel Lane, who lived in Greek Street, and he even endeavoured to learn sign language to facilitate communication. Another friend was the elderly William Redmore Bigg, who lived in Great Russell Street with a poor-sighted wife. Then there were those whom Maria described as 'loungers': Peter Coxe, author of the dreary poem, *The Social Day*; and the Reverend Thomas James Judkin. Judkin we have already met briefly, and we shall do so again at the end. He had time on his hands and was utterly devoted to Constable and his paintings. He strove to imitate Constable, and even though Constable was perfectly frank with his criticisms the devoted Judkin always came back for more. As Constable told Fisher, Judkin 'is a sensible man, but he will paint'. At the other end of the social spectrum of Constable's friends there was Sir George Beaumont who had a London house in Grosvenor Square; and Dr John Fisher, Bishop of Salisbury and uncle to Constable's dearest friend. Constable had given some painting lessons to the Bishop's daughter, Dolly; and the Bishop had commissioned another version of *Salisbury Cathedral from the Bishop's Grounds* which he gave as wedding present to Elizabeth, another daughter. There was also Louisa, Countess of Dysart, who had given the job of warden of her woods to Golding, Constable's brother (who had a habit of getting into scrapes with an unpleasant employee of Lady Dysart's, Mr Wenn). The Countess would suddenly command Constable to see her and Constable would drop everything and hurry to her house in Pall Mall.

Arrowsmith returned to see Constable with another dealer, Charles Schroth, whose Paris premises on the Rue de la Paix were visited by Delacroix and Bonington. The two men bought seven more pictures for £130. Arrowsmith fussed about over the packing of the pictures to go to France, and on 26 May Constable and Johnny Dunthorne saw them off from Charing Cross on their way to France.

Tinney, the Salisbury solicitor, also visited the studio, and now that Constable had got his way – *Stratford Mill* was on his easel for the benefit of visitors – he seems to have altered his former impression of the solicitor: 'a clever pleasant man', he now called him. Possibly this had something to do with Constable's

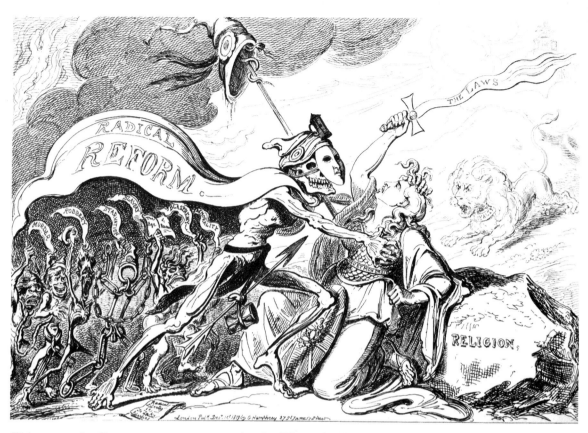

This cartoon by George Cruikshank, from the magazine *John Bull*, reflects the attitude of instinctive Tories like Constable and his friend Fisher to the prospect of parliamentary reform.

sympathy for Tinney's 'family greivance, his wife's sister having slunk off and married a nasty dirty stinking little Baptist preacher. What a calamity'. In spite of Tinney's wish that *Stratford Mill* should not be tampered with (after all, it was his picture now), Constable could not resist the temptation and even consulted Sir George Beaumont about possible improvements which were then made.

Fisher had for some time entertained the idea of visiting Paris with Constable. Tinney wanted to go over with them. But nothing came of the plan. Instead, Fisher decided to visit Constable in London. Before his friend arrived Constable went to see his family in Brighton, where he sketched in oils on paper, seated with the lid of his paint box supported on his knees as an easel, and returned in time to welcome Fisher.

With his friend in town Constable was able to talk at length; perhaps they discussed the libellous and very Tory articles in *John Bull* which they both read; they certainly ate a great deal, Constable recording meals of boiled mutton, sausages of partly cooked pork, salmon, ducks and 'lovely puddings & tarts' – consumed with sherry, claret and tea or coffee. Little wonder that as a result Fisher had to spend a day fasting. The 'droppers-in'

were in evidence: 'At tea time Peter Cox called. Johnny said I was in Brighton, still he came in – & we heard him talking loud in the painting room. Fisher got up and locked the parlor door.'

Letters arrived from Paris recording the enthusiastic reception of Constable's paintings. Arrowsmith wrote: 'no objects of art were ever more praised or gave more general satisfaction than your pictures'. Constable received a letter from Schroth addressed to 'Monsieur John Constable, Peintre paysagiste'. 'Can there be anything more amusing than all this?' he wrote to Fisher.

Constable went down to Brighton for Minna's fifth birthday, and in spite of his initial reactions to the place he soon found subjects to paint, particularly windmills on the Downs. On the day after he had taken Maria to see the Devil's Dyke (a scene which impressed him too much to paint: 'It is the business of the painter ... to make something out of nothing', he told Fisher), *The Hay Wain* went on exhibition at the Salon and prompted both critical debate and the award of a gold medal to Constable from Charles X. Constable, however, was not to learn of the excitement until later.

Maria and the children returned home. Constable's spirits were high, but by November his anxiety was aroused by the still uncomplete commissions for Tinney, and he asked to be freed from his obligations. Tinney, not surprisingly, was upset. Nonetheless, he behaved reasonably, asking that *Stratford Mill* should be returned to his drawing-room rather sooner than Constable wished. Fisher intervened, and matters calmed down.

With the year drawing to its close, it was time to consider a new major painting. This was to be *The Leaping Horse*, and the work on it was made easier by the reception afforded to his pictures in Paris. He wrote to Fisher with pride about the pictures shown at the Louvre – *The Hay Wain, View on the Stour near Dedham, View of Hampstead Heath*:

My pictures in the Gallery at Paris *'went off'* with great *'eclat'* – I hope my reputation is on the advance. I have a letter this morning from Paris – informing me that on the King's visit to the Louvre he was pleased to award me a Gold Medal, for the merit of my landscapes, which is to be forwarded to me by the first opportunity – he at the same time made Sir Thos. Lawrence a Knight of the legion of honour.... I can truly say that your early notice of me – and your friendship in my obscurity – was worth more, and is in fact now looked back to by me with more heart-felt satisfaction than all of these put together.... I deeply feel the honour of having found an original style & independent of him who would be Lord over all – I mean Turner – .

And to Maria, while he was away from London on a commission for a short while: 'How funny to have a gold medal from the King

In *The Leaping Horse*, 1825, the tow-horse is jumping a cattle barrier. This is the sixth and last of Constable's grand canal and tow-path scenes, and was shown at the 1825 RA exhibition.

of France – they seem determined to make a Frenchman of me in spite of myself.'

The early months of 1825 saw the birth of Emily, the third daughter, on 29 February. Maria had been ill, and the birth was premature. Then, on 8 May, overtaken by consumption, old Bishop Fisher died at his London house in Seymour Street. He was buried in St George's Chapel, Windsor. *The Leaping Horse* was exhibited at the Academy but remained unsold, and *The White Horse*, which belonged to John Fisher, was exhibited at Lille. Constable seems to have been unwell; his favourite son John definitely was; and Constable once more sent his family to Brighton while he stayed at Charlotte Street with Dunthorne, who this time was boarded out because, as he told Fisher, 'he is too good for my maids'. Fisher advised: 'Whatever you do, Constable, get thee rid of anxiety. It hurts the stomach more than arsenic.'

Constable reported back to Fisher that he was 'hard and fast on my "*Waterloo*" which *shall be done* for the next exhibition – saving

only the fatalities of life'. *Waterloo Bridge* was a subject he had had in mind for a long time; its successful execution meant much to him. On 19 November 1825 he wrote to Fisher:

My Waterloo like a blister begins to stick closer & closer – & to disturb my nights.... 'Go on', is the only [voice] heard.... Tinneys letter has cut me deeply.... Is his old wife at the bottom of all this? But no matter – I am [reconciled] to myself – but still hearing the order above – '*go on*' – '*go on*'....

Arrowsmith has a room in his house called Mr Constable's room – I shall contribute no more to its furniture.

Constable seems to have been suffering from more than his usual state of anxiety in 1825, and its two severest manifestations were his disagreements with Tinney and Arrowsmith. Constable wanted

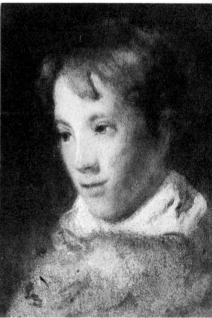

Emily Constable, the artist's third daughter, and John Charles, his eldest son.

Tinney's *Stratford Mill* to go to an exhibition in Edinburgh, but the picture remained with the Tinneys and it irritated him. Then Arrowsmith arrived with a friend, an amateur artist (the very word 'amateur' was enough to infuriate Constable), and, according to Constable, Arrowsmith used 'language as never was used to me at my easil before.' He lost his temper and Arrowsmith retreated, startled. As rumours were spreading about Arrowsmith's bankruptcy the business link was broken. All of this brought an angry sort of letter from Fisher. But, as usual, this tolerant man was prepared to forgive his friend's rash and impetuous behaviour. On 21 November 1825 Fisher wrote to Constable:

We are all given to torment ourselves with imaginary evils – but no man had ever this disease in such alarming paroxysms as yourself. You imagine difficulties where none exist, displeasure where none is felt, contempt where none is shown and neglect where none is meant. What passed between you & the Connoisseur I do not know; if he took liberties, you acted quite right; & will probably raise yourself by vindicating [your] dignity. But poor Tinney you utterly [here a line from the original letter is missing] tenacious of property & had rather see his picture on his own walls than hear of it in Edinburgh. He recollected my simile I dare say, & thought that getting his picture out of your hands was not unlike the gauze handkerchief in the bramble bush. – So he wrote to the institution. He says you are a develish odd fellow. For you get your bread by painting. – He orders two pictures leaves the subject to yourself; offers ready money & you declare off for no intelligible reason. All this he says and thinks. But as for my wrath against you, or contempt for you, it is the shadow of a moon beam. Come hither before your wife & children arrive or I shall never see you. I hope the dose of bitters I have administered above will be of service.

<div align="center">

Yours ever in all moods,
John. Fisher.

</div>

Waterloo Bridge progressed, and yet it took its toll. Constable's reply to Fisher, dated 26 November 1825, reveals a touch of paranoia:

You got me originally into the scrape, by an act of friendship. You might have lent me a helping hand to have got me out of it....

My master the publick is hard, cruel & unrelenting, making no allowance for a backsliding. The publick is always more against than for us, in both our lots, but then there is this difference. Your own profession closes in and protects you, mine rejoices in the opportunity of ridding itself of a member who is sure to be in somebodys way or other.

I have related no imaginary ills to you.... I live by shadows, to me shadows are realities.

Sensibly, Fisher let his friend be and did not write again until replying to a letter from a chastened Constable wishing him a Happy New Year 1826.

Constable's work had been represented at an exhibition in Lille by Fisher's *The White Horse* among other paintings, and in the middle of January he was able to tell Fisher that he had won a second gold medal. Yet, in spite of recognition by the French, he failed to gain election as Royal Academician (he was still an Associate) in February. It did not deter him from setting about work on a new large painting, *The Cornfield*, on which he was engaged throughout most of February and March.

The Cornfield, which had temporarily engaged Constable's attentions at the expense of *Waterloo Bridge*, was described by him to Fisher just after he sent it to the Academy as

inland – cornfields – a close lane, kind of thing – but it is not neglected in any part. The trees are more than usually studied and the extremities well defined – as well as their species – they are shaken by a pleasant and healthfull breeze – '*at noon*' – 'while now a fresher gale, *sweeping with shadowy gust the feilds of corn*' &c &c.

Study of Sky and Trees, made in about 1821. Constable wrote to Fisher on 23 October 1821: 'I have done a good deal of skying. . . . The sky is the source of light in Nature, and governs everything . . . my skies have not been neglected, though they have often failed in execution, no doubt, from an over-anxiety about them, which will alone destroy that easy appearance which Nature always has in all her movements.'

(The incorrect quotation is from Thompson's *Seasons*.) The path in the picture is the one Constable had walked from home to school, a quarter of a mile from the church at East Bergholt. The church tower in the picture has sometimes been thought to be that of Dedham, but in fact it bears no resemblance to the actual tower, and Constable included it as a pictorial device. The species of plants are indeed 'well defined': while he was working on the picture, he received a visit from a friend, Henry Phillips, the botanist, who wrote to Constable on 1 March 1826:

I think it is July in your green lane. At this season all the tall grasses are in flower, bogrush, bullrush, teasel. The white bindweed now hangs its flowers over the branches of the hedge; the wild carrot and hemlock flower in banks of hedges, cow parsley, water plantain, &c; the heath hills are purple at this season; the rose-coloured persicaria in wet ditches is now very pretty; the catchfly graces the hedge-row, as also the ragged robin; bramble is now in flower, poppy, mallow, thistle, hop, &c.

The painting was originally called *Landscape* when it was exhibited at the Academy; then Constable changed the title to *Landscape: Noon* for the exhibition at the British Gallery. Finally, once the picture reached the National Gallery in 1837, after Constable's death, the popular title of *The Cornfield* was selected, and as such it is known now. It was well received at the Academy with one exception: Chantrey, the sculptor. Lucas tells the story:

When the picture of the Cornfield was at Somerset House previous to the opening of the exhibition Chantrey came up and noticing the dark shadows under the tails of the sheep, suddenly said 'Why Constable all your sheep have got the rot, give me the pallet, I must cure them.' His efforts made all worse, when he threw the pallet at Constable and ran off.

It is likely to have been Constable's palette rag Chantrey grabbed, rather than the palette itself. The sculptor seems to have enjoyed jokes at Constable's expense, and no malice was intended. Constable says: 'Presently he came back & asked me if I had seen a beastly landscape by Reinagle (RA) – it is so indeed.'

Maria was well enough to bring the children to Charlotte Street for the summer, and Constable resumed work on *Waterloo Bridge*.

Two bits of bad news concerned Maria's father, who had an attack of apoplexy at the end of June, and Schroth, who fell victim to the economic depression in France and had to sell off his stock of pictures at very low prices to cover his debts. Beckett calculates that more than twenty pictures by Constable were now in France, and this was enough to sustain his reputation there for some time to come. Charles Bicknell's seizures may have been brought on by fears of dire impoverishment which, as it turned out, were false, and in spite of his age, seventy-four, he was able to accept hospitality without difficulty. Of Constable's other friends, we know that Johnny Dunthorne was painting a sign for the Duke of

In *The Cornfield*, of 1826, the lane in the foreground is the one Constable used to take on his way to school. The landscape, with its church tower, bears otherwise slight resemblance to the actual landscape.

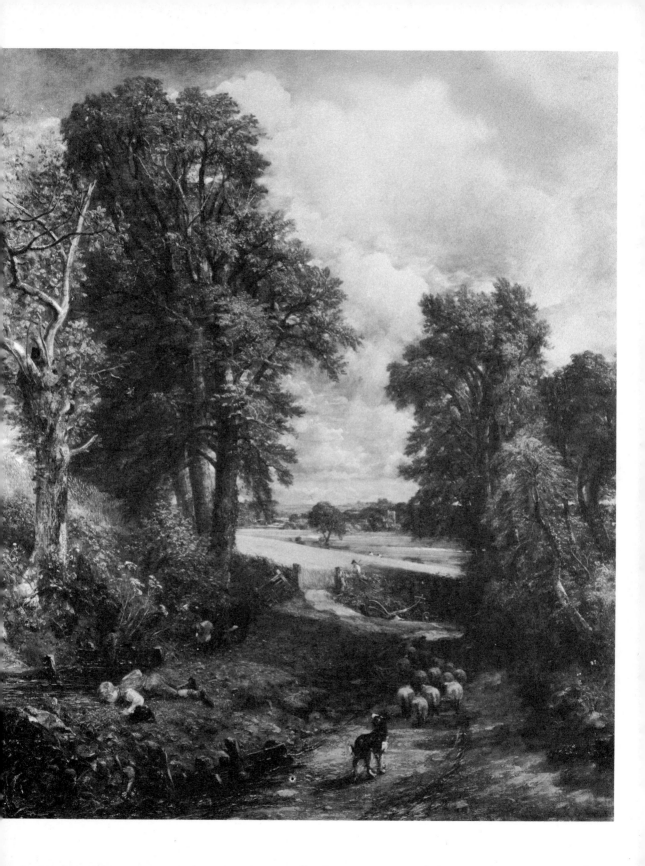

This *Seascape Study with Rain Clouds* was painted, in oil on paper, on one of Constable's visits to Brighton between 1824 and 1828.

Marlborough inn at Dedham, and the Rev. Thomas Judkin composed a sonnet in the painter's honour:

> *Thy genius is the law of thy command*
> *And doth enthrone thee with the great and wise*
> *In Art –*

Fisher moderately concluded that such lines came 'under that figure of speech termed *nonsense*'.

On 14 November 1826 Maria produced a third son, Alfred Abram, and the boy's father said, 'I am now satisfied and think my quiver full enough.' This thought led him to look for a permanent home at Hampstead. Here, next year, Constable completed *The Chain Pier, Brighton*, which received no critical acclaim and remained unsold. To make matters worse little Alfred caught whooping cough, and Constable was for a while unable to obtain proper medical advice. He told Fisher:

I was advised (by an American) to hold the boy *down the privy* for a quarter of an hour every morning – as a certain cure. Another certain cure was to put him 3 times *over* & 3 times *under* a donkey.

By the end of August 1827 Constable managed to let the upper rooms of the Charlotte Street premises to Mr Sykes, a dancing

(*Opposite*)
A sketch of John Charles and Minna boating, made during Constable's holiday with them at Flatford in 1827.

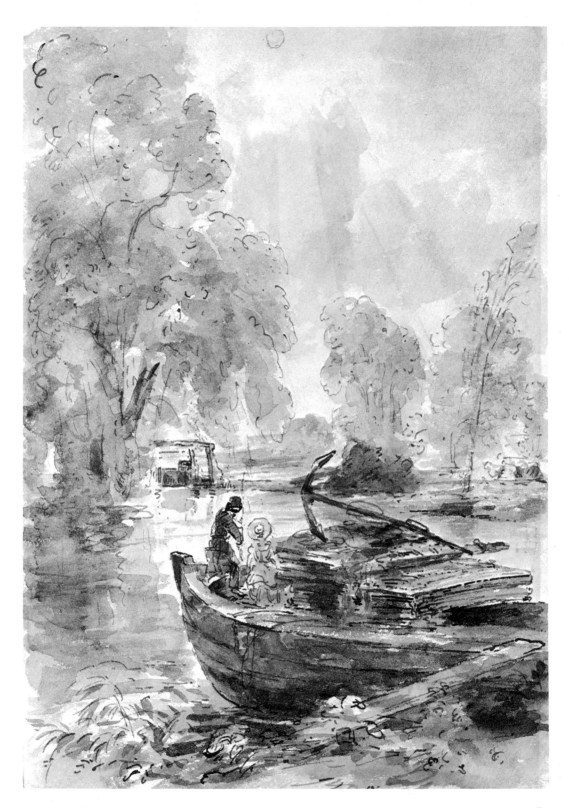

Constable's house in Well Walk, Hampstead. On 26 August 1827 he wrote to Fisher: 'I am at length fixed in our comfortable little house in the "Well Walk", Hampstead – & we are once more enjoying our own furniture and sleeping in our own beds.' He went on to detail the expense of the house, and worked up to an appeal for a £100 loan: 'I throw myself my dear Fisher on you – in this case – the weight of debt to me is next to the weight of guilt. *Help to establish me in this house!'* Fisher, who at the time had no money, tried to borrow £100 for Constable, but failed. Three months later he came to London with all he could muster for his friend, £30.

(*Opposite*)
Dedham Vale was painted in 1828 and exhibited at the Royal Academy that year. Constable called it 'perhaps my best'.

master, and moved his family to Well Walk, Hampstead. From here he wrote to Fisher that his plans 'in the search of health for my family have been ruinous'. A break seemed called for, and Constable took John Charles and Minna to Flatford for a holiday. He delighted in showing his two favourite children 'the scenes of his boyhood'; they fished and were entertained by friends, and Minna thought the countryside much like Hampstead, except the blackberries were finer in Suffolk. John Charles was allowed to ride over to see his Uncle Golding, accompanied by a coachman. It was altogether a very successful holiday, and the first Constable had had at Bergholt since 1818. Finally the rain set in, and the rested trio returned to Hampstead.

On 2 January 1828 Maria gave birth to her seventh child, Lionel Bicknell Constable. The birth can hardly have strengthened Maria; she was in any case weakening gradually. His wife's health, and the continued strain on the family's finances as well as the death of his old friend, Sir George Beaumont, depressed Constable still more. He tried yet again for election as Royal Academician but was beaten decisively by William Etty on 9 February 1828, having canvassed harder than usual, something he thoroughly disliked doing. At the same time, Sykes, the dancing master, got behind with his rent and eventually left the rooms he had been using in Charlotte Street. Then, just when financial difficulties seemed insoluble, there was some relief when Charles Bicknell died on 9 March and turned out to have been wealthier than everyone had thought. He left Maria something in the region of £20,000, a very considerable fortune. Apart from the obvious benefits, this meant that Constable could work on his six-foot canvases, those which were difficult to sell, with an easier mind; at last he was freed from the necessity of undertaking commissions. He made arrangements to have the money settled on Maria and the children. In June he got in touch again with Fisher after a break in communications of some six months. Constable reported that his picture *Dedham Vale* ('perhaps my best') had been exhibited at the Academy and that a view of Hampstead, rather surprisingly, had been bought by Chantrey (although, later, he seems to have changed his mind and did not complete the purchase). He told Fisher about the 'golden visions' of Turner in the exhibition and Etty's contributions – 'a revel rout of Satyrs and lady bums as usual, very clear and sweetly scented with otter of roses – bought by an old Marquis (Ld Stafford) – coveted by the King (from description), but too late.'

The cheerfulness was short-lived. Maria's coughing worsened; she grew feverish in the nights, and throughout the summer she wasted away. She was taken to Brighton for a while but the sea air proved of no use. The American artist Charles Leslie, ARA,

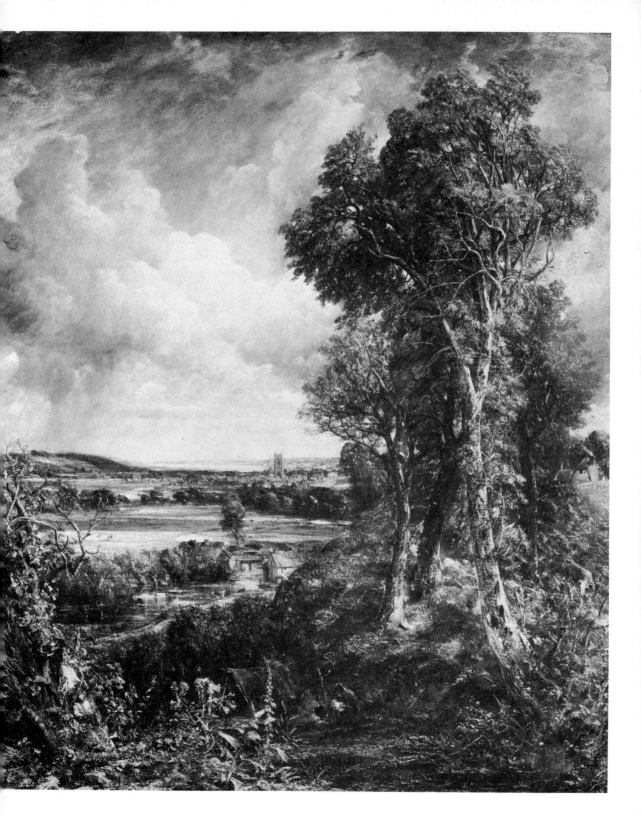

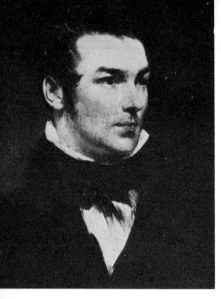

Charles Robert Leslie, ARA, Constable's American-born friend and devoted biographer, and his wife Harriet (both portrayed here by Leslie himself), became friends of Constable's not long before Maria's fatal illness.

(*Opposite*)
This portrait by Constable is believed to be of his wife, about a year before her death in November 1828.

and his beautiful wife Harriet had by now become good friends to Constable. Leslie described a visit he made to the house in Well Walk in November:

She was then on a sofa in their cheerful parlour, and although Constable appeared in his usual spirits in her presence, yet before I left the house, he took me into another room, wrung my hand, and burst into tears, without speaking.

Johnny Dunthorne stayed close by Constable, helping him with everyday things. The end came on 28 November.

Maria was buried at Hampstead. Constable told Golding: 'I shall never feel again as I have felt, the face of the world is totally changed to me.'

He took the children to Charlotte Street and replied to the many letters of condolence. The family wanted him to come to Bergholt, but the memories the place would revive had yet to be faced. Fisher advised him to bury himself in work. For the time being Constable concentrated his attentions on his seven children. He was helped greatly by Mrs Savage, the housekeeper, and Mrs Roberts, the nurse known by the children as 'Bob'. Fisher visited him, but most of all the Leslies cared for him, and Constable leaned on the strength of the American, described as 'a tall gaunt man, with dark hard features, recalling the followers of the founder of Pennsylvania'. He always dressed in black and wore wide black and white striped stocks. Constable, as we have seen, did not have a large circle of friends; people either liked or disliked him intensely. As Leslie said, his friends 'compensated for their fewness by their sincerity and their warmth'. The calm Leslie, sometimes considered cold probably on account of his reserve and natural dignity, stood by Constable when his support was most needed.

Now Maria had gone, Constable felt rather less bothered about becoming a Royal Academician. He had been rejected, often with the contempt of very large majorities, for eleven years and had been forced to see himself beaten by nonentities. Victory did in fact come on 10 February, next year, in 1829 – but only by one vote. The news of his success was brought round to him at Charlotte Street by none other than Turner who stayed talking into the early morning hours. A few days later Abram wrote to tell his brother of the family's delight at the news:

now you are what you ought to have been years ago, R.A. . . . You may & I hope will, benefit by the attachment of R.A. to your name, but your Pictures will not need any other aid than their own intrinsic genuineness & worth. . . . I think they will long be look'd at with pleasure by lovers of art and nature.

The one conspicuously discordant note was struck by Sir Thomas Lawrence, who told Constable that he had been lucky in view of the

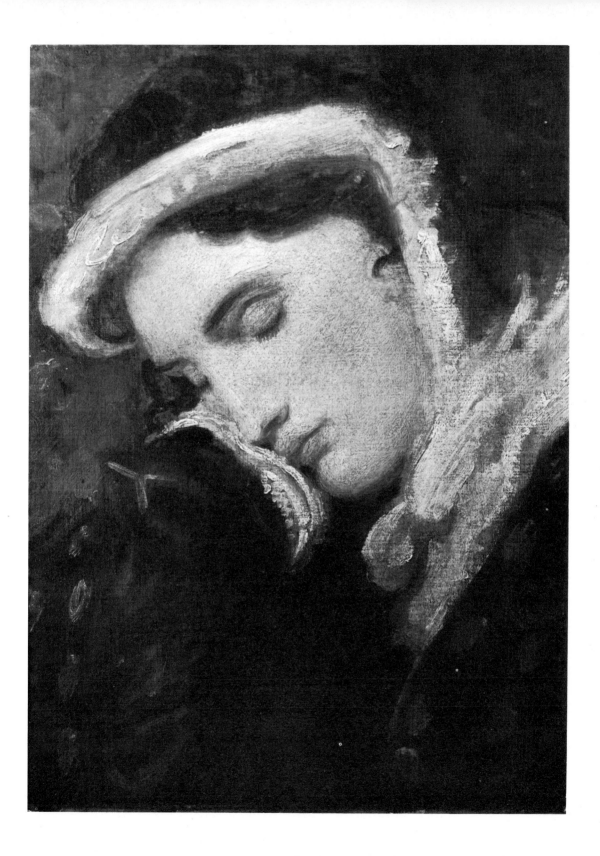

great number of meritorious historical painters who were his rivals. This led Constable to tell Leslie, as late as April, that he was 'still smarting under [his] election'.

He had just finished *Hadleigh Castle*, and this went to the Academy Exhibition. It bore the traces of Constable's device of painting white dots on the canvas to increase the sense of what he described as 'dewy freshness'. Turner said it looked as if whitewash had fallen on the picture from the ceiling, and 'Constable's white-wash' became the catch-phrase among the Academicians, who enjoyed acid humour. Not surprisingly, Chantrey had a go at glazing the picture to remove the 'whitewash'. Constable let him try and promptly restored the original effect once Chantry had gone his way. It can hardly be coincidental that *Hadleigh Castle* conveys so great a sense of loneliness. (The sun, curiously, comes from the north.) The restless sky and the cold and windblown land and sea, with the two separated and ruined towers of the castle, echo the lines from Thomson's 'Summer' which are quoted in the catalogue entry:

> *The desert joys*
> *Wildly, through all his melancholy bounds,*
> *Rude ruins glitter; and the briny deep,*
> *Seen from some pointed promontory's top,*
> *Far to the blue horizon's utmost verge,*
> *Restless, reflects a floating gleam.*

Gradually his grief subsided. He accepted a few invitations to friends' houses; he dined with Wilkie – an occasion rather spoiled

A Boat Passing a Lock (or *The Lock*) dates from 1826. Upon his election as a full Royal Academician in 1829, Constable was obliged to present a painting to the RA's Diploma Gallery, and he chose this picture as representative of his work.

for him by the presence of Reinagle and Collins: Constable was far from well disposed towards either of them. In the summer he took John Charles and Minna to Salisbury where they stayed with the Fishers. Here, relaxed in the company of his old friends and pleased by Minna's obvious delight in the surroundings, he painted *Water-meadows near Salisbury*; and judging from the calm mood of this painting his state of mind seems to have been much improved.

A new project evolved on his return to London. This was the plan to publish *English Landscape Scenery*, a selection of mezzotint engravings after a selection of his paintings and oil sketches which would help to inform a wider audience of his views on the beauties of the English countryside. He had once before entertained an idea for the engraving of some of his pictures by S. W. Reynolds. Fisher had dissuaded him by pointing out that the reproduction of his work in black and white would show the quality of his work inadequately. Then Reynolds died and the scheme was laid aside. Reynolds had, however, engraved a plate in Turner's *Liber*

Hadleigh Castle, 1829. This painting was presumed lost until it came to light some years ago in America. The cold and restless scene, lit strangely from the north, hints perhaps at Constable's grief at the loss of Maria.

Water-meadows near Salisbury was painted by Constable on his last stay there in 1829. By mistake the painting came before the R A selection committee, where it was described variously as 'a poor thing', 'devilish bad' and 'very green'. To his colleagues' embarrassment, Constable then acknowledged the work as his and withdrew it.

Studiorum; he also had an assistant, David Lucas. And, perhaps, somewhere at the back of his mind, there was the memory of the fondness that Maria had had for the velvety qualities of the mezzotint print. In some ways, Lucas must have seemed the ideal choice to Constable for the engraving and interpretation of his work. Both had a love of landscape; both had been raised in the countryside (Lucas in Northamptonshire). And Lucas, more than twenty years younger, was prepared to take orders from Constable. Furthermore, the services of Lucas were less costly to employ than those of an engraver with a more established reputation.

The two men collaborated closely on the project. Unlike Turner, who had worked on the actual process of engraving *Liber Studiorum*, Constable's role was more that of controlling supervisor, and he took the opportunity to revise the mezzotints in proof so that, in some cases, almost new works emerged. In his supervisory role Constable sketched diagrams to explain the forma-

tion of the Stour valley, showed the engraver how windmills operated, and discussed observations on natural history. The relationship became a close one. There were rows and temperamental outbursts which were frequently the result of Constable's depressions and worsening rheumatism. Lucas worked steadily and complied with Constable's instructions and changes of mind. Lucas was left to work, frequently all through the night, on the engravings which would display Constable's theory of chiaroscuro in landscape, the effective use of light and dark, to be published in five parts during Constable's lifetime and published in a final version for sale in 1838. Constable prepared an introduction with great care; it went through three drafts, and he sought the advice of Henry Phillips, whom he had previously consulted about the representation of plants in *The Cornfield*; later he had assistance from an amateur artist and visitor to Well Walk, William Purton. The greater part of the published engravings show scenes in the Constable country, others depict Hampstead, Salisbury, Brighton, Weymouth and Yarmouth.

On 7 January 1830, Sir Thomas Lawrence, President of the Royal Academy, died. He was replaced on 25 January by Martin Archer Shee, a portraitist and an Irishman. (Constable disliked portrait painters and voted against him.) It was Shee, therefore, who presided over the selection committee when Constable's *Watermeadows near Salisbury* was brought before it by mistake – for, as an Academician, Constable did not have to present his works for the committee's scrutiny. Most of the selectors demonstrated their dislike for the picture with cries of 'Out! Out!' Someone dis-

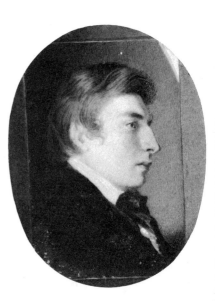

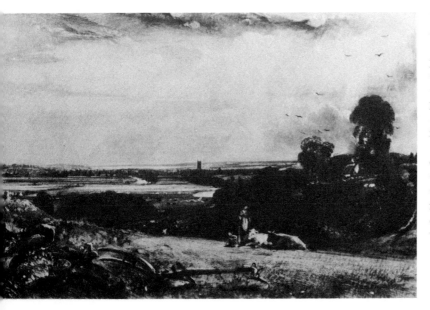

David Lucas, shown (*above*) in a miniature attributed to R. W. Satchwell, first met Constable probably in 1824. In 1829 he embarked on a series of mezzotint engravings of Constable's paintings, *English Landscape Scenery*. The example shown here is *Summer Morning, Dedham Vale*. The two men collaborated closely on the work, which cost Constable a lot of money. After Constable's death Lucas's fortunes declined; he took to drink and died in the Fulham workhouse on 22 August 1881.

agreed, and then Constable, who was a committee member, declared he had painted it. The committee at once sought to include the picture. Constable said it was too late: they had given their view – and out it must go.

The Academy seems to have brought out the extremes in Constable's obstinacy and sharpness of manner. On another occasion Leslie and Constable heard an amateur artist protest vigorously about the way his picture had been hung, and the two of them sought to pacify the complainant who burst out with accusations about the jealousy of Academicians:

'I cannot but feel as I do,' the man admitted, 'for painting is a passion with me.'

Constable did not improve matters by replying, 'Yes, and a bad passion.'

He further involved himself in the Academy, perhaps with Leslie's encouragement, in 1831 by becoming Visitor in the Life Academy. His role consisted of arranging the model, which he often did so that the figure stood in a pose from a celebrated painting, decked out with suitable landscape props for the background. As a teacher he was a great favourite with the students. (Maclise, who attended Constable's life classes, made a drawing of him at this time.) Etty, whose enthusiastic and close attentions to the naked models much amused Constable, was usually present. Constable's scenario for Eve led him to a minor scrape with Sir Robert Peel's keen police constables, as he wrote to Leslie:

I spare neither pains nor expense to become a good Academician *for your sake* – perhaps more than my own. It cost me ten shillings for my 'Garden of Eden' beside my men being twice stopped on Sunday evening by the police – with the green boughs, coming from Hampstead – thinking (as was the case) they had robbed some gentleman's garden.

'This drawing', writes Lucas on the back of it, 'was made by John Constable July 1830 to illustrate the general characteristics of the valleys of England, particularly that which divides the counties of Essex and Suffolk.' This was the drawing on which Lucas wrote down the story of the Suffolk farmhand's farewell to England (see p. 106).

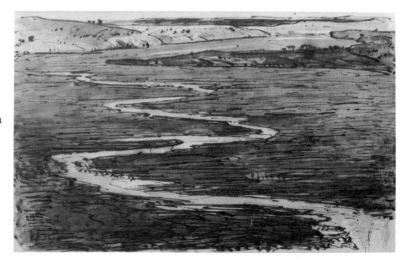

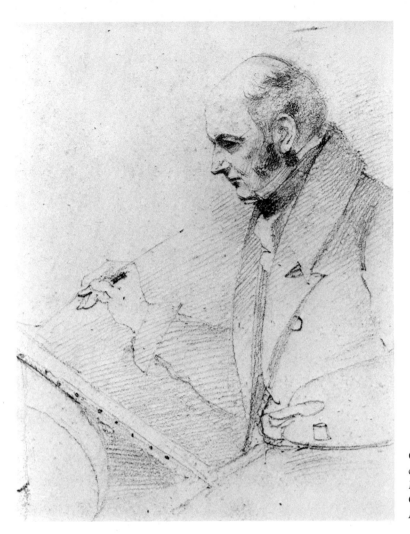

Constable late in life, a pencil drawing by Daniel Maclise, R A. Maclise was a student of Constable's at the Royal Academy.

With the coming of spring 1831 and its easterly winds, the delays of the work on *English Landscape* owing to illness in the Lucas family, and the need to complete another major work for the Academy, Constable became more depressed. He would rest only once darkness came, and then, perhaps, he would eat dinner. He slept badly; he was disturbed by the illnesses of John Charles, and his second boy, Charley; and his own repeated colds made matters worse. The local apothecary, Drew, provided Constable and his eldest son with medicine and pills; Constable took his own and his son's to speed recovery and his work on the major picture for the Academy, *Salisbury Cathedral from the Meadows*, based on sketches he had made during his stay with Fisher in 1829, his last large-scale painting of Salisbury and perhaps also his greatest. Massive and troubled clouds dominate the cathedral, relieved only by the spring of the rainbow. In the foreground are slimy posts and

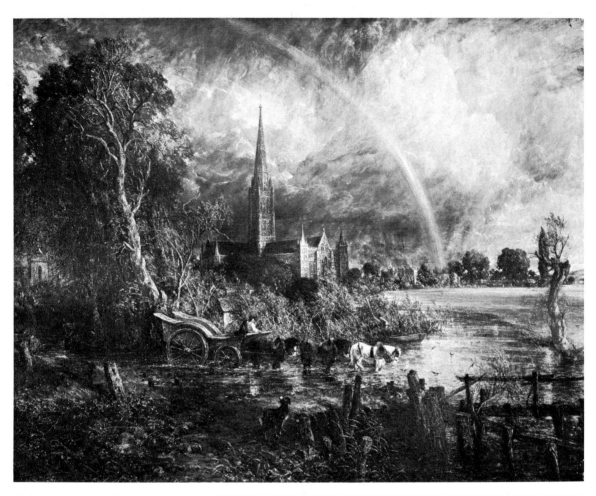

Salisbury Cathedral from the Meadows, painted in 1831, two years after his last visit to Salisbury. Fisher had described Constable's idea as 'the "Church under a cloud"'. Burdens of a personal kind troubled Constable while he was struggling to finish the picture in time for the RA Exhibition of 1831; he had a very bad cold, both Charley and young John were ill, and the mezzotints were selling badly. He continued work on the painting after the exhibition, during 1833 and 1834.

A Dog Watching a Rat in the Water, Dedham, on 1 August 1831.

stumps, horses and a cart in the water, an alert dog, birds wheeling over the water's surface.

The gregarious William Beechey visited Constable's studio and saw the work in progress; he was known for his conversational manner that largely seems to have consisted of linking expletives with what he had to say. Constable wrote to Lucas that Beechey said of *Salisbury Cathedral from the Meadows*:

'Why *damn* it Constable, what a *damned* fine picture you are making, but you looked *damned* ill – and you have got a *damned* bad cold.' So that you have evidence on *oath* of my being about a fine picture, & that I am looking ill.

The painting received sarcasm from *The Times'* critic who informed his readers that the clouds were improbable and that someone had dropped whitewash spots across the foreground: 'It is quite impossible that this offence can have been committed with the consent of the artist.' *The Morning Chronicle*, invariably ill-disposed towards Constable, thought it a 'coarse, vulgar imitation of Turner's freaks and follies'. On the other hand, on 14 May 1831, the *Literary Gazette* expressed a different opinion:

If Mr Turner and Mr Constable were professors of geology, instead of painting, the first would certainly be a Plutonist, the second a Neptunist. Exaggerated, however, as both these works [Turner's *Caligula's Palace and Bridge*, Constable's *Salisbury Cathedral from the Meadows*] are, – the one all heat, the other all humidity – who will deny that they both exhibit, each in its way, some of the highest qualities in art? None but the envious or the ignorant.

Constable had been on the committee responsible for the arrangement of the exhibition, and had apparently changed the position of

A Mouse with a Piece of Cheese (undated) recalls an entry in the journal Constable had kept for Maria when she was in Brighton in 1824: 'Johnny saw the Mouse – and he is getting very fat. I take him rinds of cheese.' As the Constables had at least two cats in the house, this mouse must have been an intrepid creature.

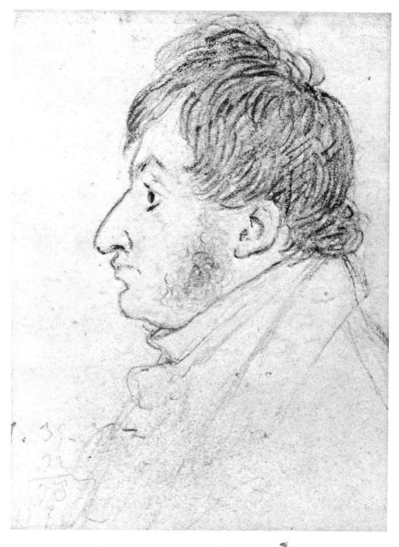

J.M.W. Turner (drawn here by
C.R. Leslie in 1816) was
Constable's contemporary
and his chief, and far more
successful, rival. Both were
regarded as eccentrics and
subjected to a great deal of
critical abuse. They were never
close friends.

Turner's *Caligula's Palace and Bridge* with a picture of his own.
He can hardly have expected Turner not to let loose his bile, and
Turner did so at the house of his patron, General Phipps in
Mount Street. According to David Roberts, a devoted follower of
Turner's:

Turner was down upon him [Constable] like a sledge hammer; it was of
no use his endeavouring to persuade Turner that the change was for the
advantage, and not his own. Turner kept at it all evening, to the great amuse-
ment of the party; and I must add, he richly deserved it, by bringing it
on himself.

In September 1831 Constable, as a Royal Academician, received an
invitation to be present at the Coronation of William IV. As a
staunch Tory and monarchist he must have thoroughly enjoyed his

eleven hours in Westminster Abbey, even though the Lord Chancellor, Lord Brougham and Vaux, whose radicalism Constable loathed, stood with his back to Constable for a whole hour, 'with his crown on, a sight than which nothing could be more ridiculous – for as his coronet was perched on top of an enormous wig, he bore the external shape of a Jack in the Green'. Constable's view of current affairs was jaundiced by the move towards reform, and the Whig government became an object of detestation, so much so that Leslie told him not to let it upset his health. Constable replied: 'No Wigg government ever did or can do good to this peculiar country – they are always the blocks as well as the wiggs – and always when in power, are our worst stumbling blocks.'

His anger and general irritability was further increased by the recurrent rheumatism which struck his left hand and side. Fourteen leeches were applied to his shoulder on 16 December and temporarily alleviated the pain; but for a while he had difficulty standing. His affections turned increasingly to Minna, who must have reminded him of Maria. He told Leslie lovingly of the affection she showed him at Christmas:

My pretty Mini dressed up my mantelpiece with X'mas [boughs] & likewise set out a little table that I might look pretty in the dining room in her absence, which I scrupulously avoid being disturbed.

In January 1832 he was confined to his bed, and the whole family set about making his troubles lighter, as he wrote to Leslie on 17 January:

How heavenly it is to wake up as I do now after a good night – and see all these dear infants about my bed all *up early* to know how papa passed the night – even little Lionel puts out his little face to be kissed and smacking his lips like a fish, says, 'Are you well-better to day.'

Etty took over his life class while he was ill, and by February Constable had regained enough strength to turn his attentions once again to *Waterloo Bridge* – a view of the scene of its opening in 1817. On 28 February he told Lucas: 'I am dashing away at the great London – and why not. I may as well produce this abortion as another – for who cares for landscape?' On 3 March he told Leslie that the picture gave him

much pleasure in the present occupations – but how long that will last I know not. Archdeacon Fisher used to compare himself in some situations, to a lobster in the boiler – very agreeable at *first*, but as the water became hotter & hotter, he was greivously perplexed – at the bottom.

Next day, he told Leslie he was 'much amused with' his 'Harlequin's Jacket' – a reference to the silver, gold and scarlet of the water and state barges.

This thumbnail sketch by Constable of Lord Chancellor Brougham, who stood in his line of sight at the Coronation of William IV in 1831, comes from a letter to C. R. Leslie.

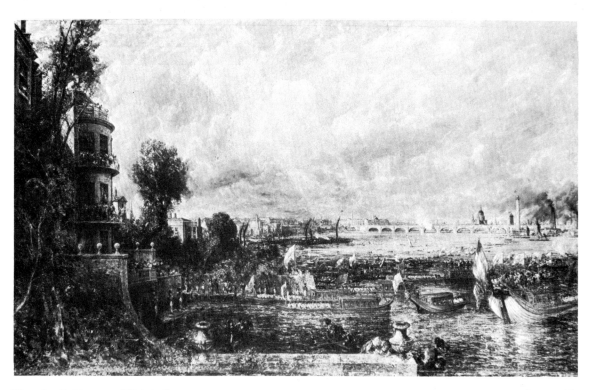

Waterloo Bridge from Whitehall Stairs, completed at length in 1832, shows the distant scene of the opening ceremony in 1817. Lively and bold in effect, it hung opposite Turner's *Helvoetsluys* at the RA in 1832.

In striving after the effervescence of the scene, Constable resorted to the palette knife, which in any case will have been less painful to hold in his hand than a brush which demanded more precision. The result led Stothard to shake his head and declare: 'Very unfinished, Sir.' *Waterloo Bridge* was exhibited at the Royal Academy exhibition in May 1832. The criticism in the press was generally favourable, with the usual exception of the *Morning Chronicle's* critic who declared on 7 May 1832:

Mr CONSTABLE, gives us notice – 'one, two, three and away,' – to be off, and we shall for the present merely say, that if any plasterers were required, he might have been better employed in the erection of the bridge itself than in painting the subject.

Turner, canny rival whose province was especially the conspicuous pictorial effect, had noticed the bold colouring of Constable's *Waterloo Bridge*. One of Turner's beautiful sea-pieces was placed opposite *Waterloo Bridge*. Prior to the opening Constable busied himself with the bright flags and decorations of his city barges, applying extra vermilion and lake. Turner looked from *Waterloo Bridge* to his own picture, and scurried off to collect his palette. He returned, gathered a blob of red lead on his brush, daubed it into the middle of his grey sea, and left Constable to his own devices. He had not uttered a word. Leslie came into the room to see Constable and looked at Turner's picture. Constable said, 'He

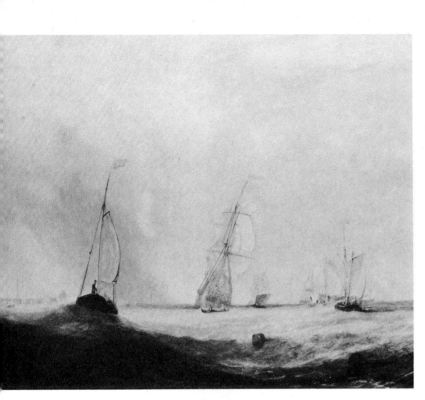

Turner's *Helvoetsluys,* the painting he touched up with an explosive touch of red (the buoy) to compete with Constable's *Waterloo Bridge (opposite).*

Turner on Varnishing Day, by Parrott, shows Constable's great rival engaged in his common practice of repainting his RA entries at the last minute before the exhibition opened.

has been here and fired a gun.' The blob of red lead had put Constable's effects in the shade. Abraham Cooper came into the room and looked about. He saw a painting by Captain George Jones RA of Shadrach, Meshach and Abednego in the furnace. Cooper said: 'A coal has bounced across the room from Jones's picture, and set fire to Turner's sea.' The blob stayed on the sea untouched for a day and a half. Then, during the last moments allowed for painting, Turner returned and transformed the blob into a buoy.

In spite of the critics, Leslie says, *Waterloo Bridge* was generally pronounced a failure; 'it was a glorious failure, however'. And a remark of Constable's found amongst his papers after his death by Leslie serves as a postcript:

My art flatters nobody by imitation, it courts nobody by *smoothness*, it tickles nobody by *petiteness*, it is without either *fal de lal* or *fiddle de dee*, how then can I hope to be popular?

In June 1832 two of those closest to him fell ill. Minna caught scarlet fever and nearly died. Mrs Roberts 'is crying all day at not being able to administer to the dear darling child's comfort', and John Charles was so upset he had to be sent away for a change of surroundings. Minna recovered slowly, stayed with the Leslies who were holidaying in Brighton, and then at East Bergholt. Johnny Dunthorne was also ill; he was troubled by a heart disease, and after he had been taken back to Suffolk he died there in October.

For the last two years the correspondence between Constable and John Fisher had somewhat fallen off. As long ago as May 1830 Constable had written of his regret about the lessening of the correspondence and put it down to 'Time and events ... and all spirits', reporting that Tinney had become 'the merest idiot: he calls himself Sir John Tinney and addresses his poor wife as Lady Tinney'. In 1832 Fisher became ill and went to Boulogne where it was hoped the change of air would set him aright. Either Mrs Fisher did not know, or she did not care to admit it; but her husband had cholera. The outcome was revealed to Constable in a letter he received at Well Walk on 3 September 1832 from John Fisher's sister, Mary:

Close – Norwich
My dear Sir,

It has pleased God to visit me with a heavy affliction in the death of my dear Brother, John – knowing the friendship which has so long subsisted between you, I should be sorry you should learn this most sad news first by the public papers.

Constable told Leslie:

John Fisher and his dogs.

I cannot say but this very sudden and awfull event has strongly affected me. The closest intimacy had subsisted for many years between us – we loved each other and confided in each other entirely – and this makes a sad gap in my life & worldly prospects. He would have helped my children, for he was a good adviser though impetuous – and a truly religious man.

God bless him till we meet again – I cannot tell how singularly his death has affected me.

I shall pass this week at Hampstead to copy the winter peice – for which indeed my mind seems in a fit state.

The 'winter piece' was a painting by Ruysdael, and Constable sought refuge from his loneliness by copying it. Fisher's name was none too widely known at the time of his death; indeed, it is none too widely known now; but the extent of his generous, thoughtful and above all kindly influence upon Constable's art and life were repaid if not albeit entirely in his lifetime then certainly after it. As monitor of Constable's ideas about art and nature Fisher had played a key role in the development of his friend's career; above all, he had bolstered Constable's confidence in his own ability. Geoffrey Grigson puts the case for Fisher's influence in his preface to the collected correspondence between the two men, and few readers of those letters will seek to question Mr Grigson's conclusion:

Is it fanciful to suggest that without the Archdeacon's friendship the painter's achievement would never have been so thorough? If that is so, then the Archdeacon in his Dorset parsonage or in Salisbury Close had his moiety of influence upon a hundred years of European painting.

SONGS,

DIVINE AND MORAL.

ATTEMPTED IN

EASY LANGUAGE.

The half-title of *Songs Divine and Moral* (1832), by the Rev. Isaac Watts, decorated by Constable as a birthday present for Emily in 1833.

Perhaps the loss of his friends led Constable to experiment with different subject matter. Salisbury, as a theme, had as it were been rounded off. *Waterloo Bridge from Whitehall Stairs*, to give it the title it now has, was now complete, some fifteen years after the original idea for it had taken hold. In 1832 he visited Englefield House in Berkshire, which he painted for Mr Benyon de Beauvoir. This was a rather lifeless creation of which he said to Leslie: 'My House tires me very much. The windows and window frames & chimney pots are endless – but I shall fill the canvas beyond repentance.'

And the loss of friends must have also directed his attentions to his children. At the Academy, in the presence of fellow artists, and in his dealings with Lucas and others, Constable sometimes allowed his moodiness and sharp tongue to get the better of him,

Charlotte St. March 27. 1833

Dear Charles.

Mr Bonner and John having finished there letters to You – to wish You many happy returns of that same". I now take up my pen to do the same – also wishing all the health and happiness that it may please God to bless You with – I well remember Your birth day – I was about the large picture of the Waggon crossing the river which went to paris – and for the painting of which I received the Legion of my gold medal – inscribed with my name "John Constable peintre du paysage London" – I have been much pleased with Your letter – and the little sketches which You now and then put into them which explains what You mean very well. The Vice – and the Indiaman & the Ships in the downs – and Dover – over and over again – I did not know You would be able to see so much of the Shipping in the Downs.

A letter from Constable to his eldest son John Charles, dated 27 March 1833.

but the reverse seems to have been the case in his treatment of the children. Minna we have already heard much about, as well as John Charles who was perhaps the most reflective of the children and the one most prone to sickness. The rest of the children were lively; they were often joined by Leslie's son, Robert, in the canopied playground Constable had erected at the back of the Charlotte Street house. Among the toys provided for the children was a working model fire engine. Robert Leslie later remembered

how one of the older boys, after cutting holes in a large box to represent a house with windows, filled it with shavings and set fire to them. Another boy then rang a small bell, and the model engine appeared, but had scarcely begun to play upon the flaming box when Constable, to whose studio the dense smoke had found its way, came among us, and saying, 'I can't have any more of this,' looked for a can of water to put out the

fire; while the author of the mischief coolly turned the hose of the little engine on to the back of his father's head; who in place of being furious with the boy, as I expected, appeared to think it rather a good joke, and, after extinguishing the fire, quietly went back to his painting room.

The diversionary tactic of creating a playground outside does not appear to have succeeded wholly in preventing the children from invading Constable's studio. The Rev. Julian Young, whose uncle, George Young, a surgeon, was a friend of Constable's, records a visit of his uncle's to Charlotte Street in 1824:

After half an hour's chat the artist proposed to repair to another room to show him a large picture on which he had been engaged. On walking up to his easel, he found that in his absence one of his little boys had dashed the handle of the hearth-broom through the canvas, and made so large a rent as to render its restoration impossible. He called the child up to him and asked him gently if he had done it. When the boy admitted that he had, he rebuked him in these unmeasured terms: 'Oh! my dear pet! See what we have done! Dear, dear! What shall we do to mend it? I can't think – can you?'

Although Constable eventually sent the boisterous Charley away to boarding school near Folkestone, he employed the services of a tutor, Charles Boner, for his other children. Boner was greatly liked by the whole household and not only taught the children but was engaged on taking urgent letters, making packing cases and helping with the text for *English Landscape*. Even his serious-mindedness appealed to Constable, a trait which sometimes led him to misunderstand Constable's jokes. Constable told Leslie that he mentioned a friend whose wife was pregnant: 'I told Boner that Evans had *poisoned his wife*. He looked quite frightened and said, "Indeed! has he given everything by mistake?"' Slowly Boner became indispensable. He acted as a kind of secretary, supervised the servants and showed patrons pictures. He also intervened in a row between Constable and Lucas, over the fate of Lucas's rejected prints.

Charley thoroughly enjoyed school at Folkestone, and Constable sent John Charles there to join his brother. The girls attended a day school, and with his family about him Constable seemed contented enough. *Englefield House* appeared at the RA in 1833, and even the bilious *Morning Chronicle* critic allowed himself to observe that Constable had spared the whitewash – 'We hope he has lost the brush.' However, the painting was disliked by Mr de Beauvoir, who decided not to take it. A greater sense of regret overtook Constable when Leslie told him he had decided to return to America to take up an appointment at West Point which offered him a more settled life. Constable wrote to him:

The loss of you is a cloud casting its shade over my life, now in its autumn. I never did admire the autumnal tints in nature, so little of a painter am I in the eye of commonplace connoisseurship – I love the exhilerating freshness of spring.

Constable's letter is dated 11 June 1833, his fifty-seventh birthday. Leslie sailed from London in the *Philadelphia* and reached New York five weeks later.

During the summer of 1833 it was suggested to Constable that he might address the Literary and Scientific Society of Hampstead on a subject of his choice. He chose 'An Outline of the History of Landscape Painting'. All Constable's lectures were delivered from brief notes; Constable would talk for up to an hour and a half and reinforce the ideas he had to convey by referring to copies of masterpieces he had selected; he made a point of drawing his audience's attention to the nature of the day's weather. Two years later he lectured at the Worcester Literary and Scientific Institution. The lectures were a great success, and in 1836 Constable gave four more at the Royal Institution before an invited audience of people considered eminent in art and science, including Michael Faraday. (An invitation was sent to Wordsworth, but it is not known whether he attended.) The lectures at the Royal Institution show Constable's respect for tradition, tempered by his insistence that it should not overpower the artist; and his two celebrated appeals for a 'scientific' approach to painting, even if

Christopher Columbus Explaining the Project for the Discovery of the New World, in the Convent of La Rábida, painted by Sir David Wilkie, RA, in 1834; Constable was the model for the bald man, second from the left, who is the physician García Fernández.

they were not then heard, were taken up by the French in the latter part of the century:

Painting is a science, and should be pursued as an inquiry into the laws of nature. Why, then, may not landscape be considered as a branch of natural philosophy, of which pictures are but the experiments? In such an age as this, painting should be *understood*, not looked on with blind wonder, not considered only as a poetic aspiration, but as a pursuit, *legitimate, scientific, and mechanical.*

Leslie, it will be recalled, had gone to America. But when he got to West Point he found he had been provided with an attic in which to live, and that life in America was far more expensive than he had bargained for. Then Mrs Leslie fell ill. So he decided to return to England, sailed on the *Philadelphia* on 14 April 1834 and with favourable winds reached England twenty days later. He moved into a London house in the Edgware Road, where Constable was able to pay his family visits. Robert Leslie remembered:

The house had then an open stretch of sweet-smelling hayfields in front of it, extending to Harrow on the Hill, and I can see Constable now as he used to sit on a summer evening in the front room, sipping what he called a 'dish of tea', and admiring a sunset beyond a row of fine oaks and elms. After which he and my father spent the rest of the evening in the painting room.

In 1834 and 1835 he visited a new-found friend, a brewer and amateur artist, George Constable – no relation – who lived at Arundel in Sussex. He wrote to Leslie:

New waterworks buildings and Arundel Castle today, from approximately the viewpoint adopted by Constable in his last painting (*opposite*).

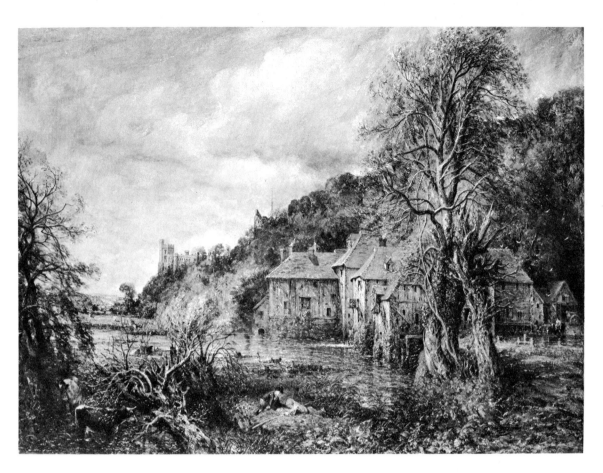

The Castle is the cheif ornament of this place – but all here sinks to insignificance in comparison with the woods, and hills. The woods hang from excessive steeps, and precipices, and the trees are beyond everything beautifull: I never saw such beauty in *natural landscapes* before. I wish it may influence what I may do in future, for I have too much preferred the picturesque to the beautifull – which will I hope account for the *broken ruggedness of my style*. Some parts of the Castle, such as the keep and some old walls, are as grand as possible – but the more modern part is not unlike a London show place, or tea garden.

During this visit he went to Petworth, and next month he returned there with Leslie to stay with the octogenarian Lord Egremont. Egremont seems to have entertained the idea of having both Constable and Turner under his roof at the same time. But Turner is said to have told Egremont that 'he was off to the *north* on a booksellers job, that was a profound secret'. One morning, when Constable had already left to go sketching, Leslie went into his friend's room: 'His dressing table was covered with flowers, feathers of birds, and pieces of bark with lichens and mosses adhering to them, which he had brought home for the sake of their beautiful tints.'

Arundel Mill and Castle is the painting on which Constable worked on 31 March 1837, the day of his death. He was anxious to complete it in time for the RA Exhibition; in the event it was shown posthumously. Leslie wrote: 'The scene was one entirely after his own heart, and he had taken great pains to render it complete in all its details; and in that silvery brightness of effect which was a chief aim with him in the latter years of his life.'

105

Constable paid a visit to East Bergholt early in 1835 prior to beginning work in earnest upon *The Valley Farm*, his last major picture of the Constable Country. It was exhibited at the Academy and bought by Robert Vernon, a self-made man who had secured a substantial fortune from horse-dealing during the Napoleonic wars. Vernon saw the picture in March in Constable's studio. Vernon wanted to know if the picture had been painted for anyone in particular. 'Yes, sir,' Constable told him. 'It is painted for a very particular person – the person for whom I have all my life painted.' Vernon paid the handsome sum of three hundred pounds. The picture was exhibited at the British Institution next year (1836), Constable having made alterations to it. Eventually, it went to Vernon's house in Pall Mall and then, in 1847, it was presented along with 156 other pictures to the nation, went to Marlborough House, then the South Kensington Museum and finally to the National Gallery. Today it is in the Tate Gallery.

Two departures now took place. Firstly, Charles Boner returned to Germany (where his father had originally come from). He was only nineteen, and during the subsequent decades he earned something of a reputation as a poet. (Wordsworth noted his work with approval when Boner met him in the Lakes during 1844.) He became tutor to the family of Prince Thurn and Taxis, for whom he served as unofficial adviser on continental politics. Like Lucas, Boner preserved every bit of paper he possessed which bore Constable's marks or handwriting.

Secondly, Charley Constable was enrolled as midshipman in the East India Company's ship *Buckinghamshire*. Abram Constable, his uncle, put up some money for the boy's uniform. 'I wish Charley well at sea –,' Constable wrote to Leslie, 'for his own sake. He is an extraordinary boy, and if his genius does not destroy him, it will be the making of him – but my *fear* is more than my *hope*!!' Constable began to pine for his son even before he left home. The father had never left England, and when, around this time, he drew a diagram of the Stour Valley for Lucas's benefit, he told him the story of an old Suffolk man who crossed the river into Essex, and looking back the way he had come, said: 'Good-bye, old England, perhaps I may never see you more.'

Charley tried on his uniform and his father painted him in it. 'Poor dear boy –', the father wrote to Leslie. 'I try to joke, but my heart is broken. He is mistaken by all, but you & me – he is full of sentiment & poetry & determination & integrity, & no vice that I know of.' The father went to the docks with his son, young Alfred, and 'Bob' the nanny. Constable went on the deck of the *Buckinghamshire* and his son stayed close by him and asked if his father would stay with him until the next day. But they shook hands, Constable turned and took himself away from his son who

The Valley Farm, showing Willy Lott's cottage at Flatford, was painted after Constable's last visit to East Bergholt in 1835.

106

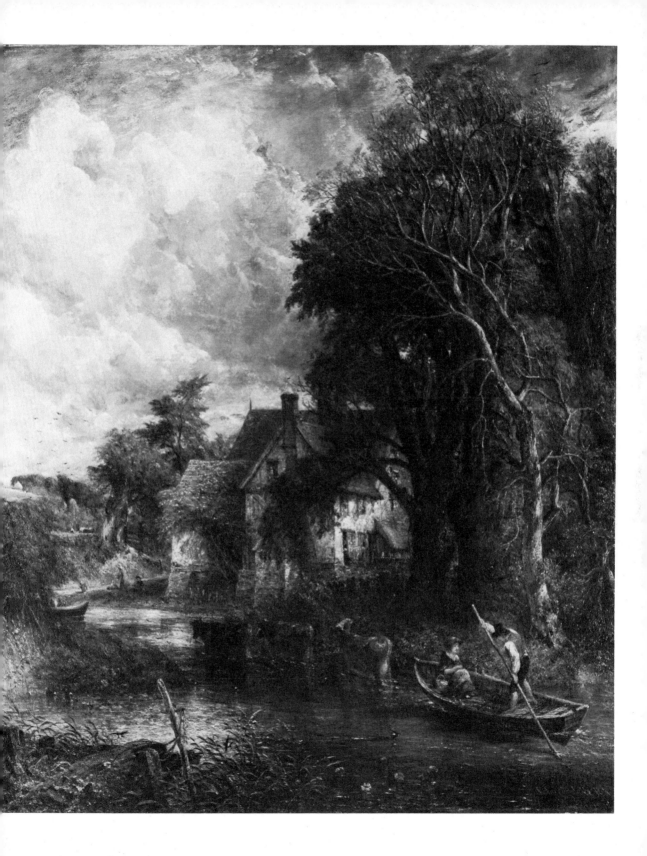

View on the Stour with Dedham Church in the distance, a sketch in sepia wash and pencil made by Constable sometime between 1830 and 1836 during the last years of his career. This is a fine example from the by no means widely known series of dramatic and moving monochrome sketches Constable made of the Constable Country, using a violent contrast of light and shade, and a composition refined perhaps from those he had used over thirty years before.

was just fourteen years old. The final letter from Charley on this voyage was written off the coast between Portsmouth and Plymouth on 8 September 1835. From his letter we gain an impression of his first duties:

Dear Papa,

I take this opportunity of writing to you by the Pilot who has not yet left the ship. It is blowing exceedingly hard and allthough I have been trying to write this all day yet I have not left the Topp till now 4 o'clock except to dinner, there has been nothing but 'Let go this', 'Hold on that', 'Now young gentlemen, up on the missen topsail yard, come Mr Constable', &c &c.

The ship gave such a lurch today that the main chain's come up full of water, it has been raining all day, the Pilot cutter is following us, it is as much as she can do to stand it, she dips forecastle under.... We have a great many gentlemen passengers on board to day, some of them had a hearty laugh at seeing my cap blow far away to leeward from the mizzen and just after went my right shoe.

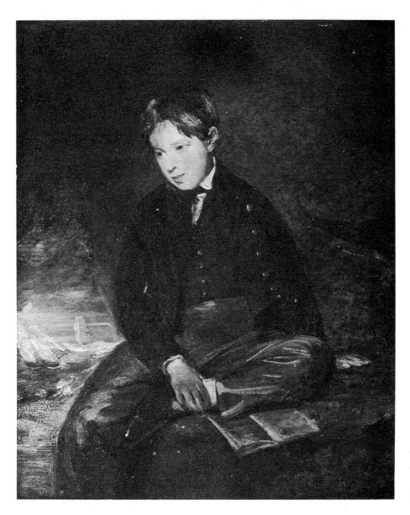

Charles Constable, the artist's second son, painted in September 1835 in the uniform of an East India Company midshipman.

The contents of the letter were conveyed to Leslie by the father, who showed unbounded pride in Charley even though he had lost his cap and shoe. 'He is a true sailor,' the father told Leslie, 'he makes up his mind to combat all difficulties in calms or storms with an [evenness] of mind – which little belongs to me, a landsman.' But at least Charley was not in the navy proper, a service seen by Constable as 'a hateful tyranny, with starvation into the bargain'. When Leslie included the story of Charley's missing cap and shoe in his life of the sailor's father, Charley was far from pleased and the anecdote was excluded from the second edition.

John, the artist's eighteen-year-old eldest son, had been on a trip to France where he disliked the food and noticed little of the pictures in the Louvre except of Watteau in whose *Embarquement pour Cythère* the young John Constable saw 'ever so many cupids & people were flying about the sky & climbing up the mast of a boat'. In London, young John continued his medical studies by

day and in the evenings became his father's close companion. Perhaps this companionship led to his father's expression of scientific interests. On 10 November 1835 he made the following note:

When young, I was extremely fond of reading poetry, and also fond of music, and I myself played a little [he had practised the flute]; but as I advance[d] in life and art, I soon gave up the latter; and now after thirty years, I must say that the sister arts have less hold on my mind in its occasional ramblings from my one pursuit than the sciences, especially the study of geology, which, more than any other, seems to satisfy my mind.

Some thirty years before, he had shown a precise interest in anatomy. And bearing in mind that his son John was working under Faraday, neither Constable's lectures at the Royal Institution nor the comments he made then about the pursuit of painting 'as an inquiry into the laws of nature' and as 'a science' are wholly surprising.

Abram's business had seen reverses, though none proved too serious; and the family prospered in East Bergholt, secure in their fortunes and proud of their brother's achievements. As long ago as 1832 John had become something of a celebrity. As he had written then to Lucas:

In the coach yesterday [13 November 1832] coming from Suffolk, were two gentlemen and myself all strangers to each other. In passing through the valley about Dedham, one of them remarked to me – on my saying it was beautifull – "Yes Sir – this is *Constable's* country!" I then told him who I was lest he should spoil it.

His work with Lucas dragged on to its completion; the collaboration survived Constable's endless revisions of the mezzotints. Then, to Constable's delight, on 30 August 1836 Charley returned from the sea. He worked for a time on *Arundel Mill and Castle*, a subject he had absorbed in an unusually short time before starting a major painting of it. But at this time the new National Gallery building was almost ready, and so the exhibition in May 1837 would be the last at Somerset House. Constable took out his painting *The Cenotaph*, showing the memorial to Sir Joshua Reynolds which Sir George Beaumont had erected at Coleorton Hall, and this, along with a drawing of Stonehenge, formed the sum total of his exhibits there. (*Arundel Mill and Castle* was exhibited in the year after his death.) In the autumn, while John was preparing to go up to Jesus College, Cambridge, Charley waited for his ship to sail again, this time for China. The boat was delayed, and Constable urged Lucas to send round a proof of his mezzotint of Dedham Vale so that Charley could see it before he left: '. . . he may never see it again!!!! But God grant he may return safe.'

Constable became more depressed than ever. He wrote to his friend, the collector, James Stewart, on 25 November 1836:

The Cenotaph at Coleorton, in Memory of Sir Joshua Reynolds, is a tribute both to Reynolds and to the man who erected the monument, Constable's patron Sir George Beaumont, who died at Coleorton in 1828. One of the last works Constable sent in to the Royal Academy, in 1836, it is, unusually for Constable, an autumn scene.

I am not in the best of spirits. The parting with my dear sailor boy – for so long a time that God knows if we ever meet again in this world – the various anxieties and the fear of the world, & its attacks on my dear children after I am gone & they have no protection, all these things make me sad.

Two days later the *Buckinghamshire* sailed from Gravesend in heavy weather and Constable lay awake at night troubled deeply by dreams of shipwrecks. An early winter brought snow to London and Constable remained almost continuously indoors. He invited the Leslies to share a gift of venison from Lady Dysart at Christmas: '"Prithee come – life is short – friendship sweet." These were the last words of poor Fisher to me, in his last invitation.'

On 2 January 1837 Constable went to a party with his children at the Leslies. He worked on *Arundel Mill and Castle* throughout January and February, taking some time off to replace Turner as Visitor at the Life Academy. A note from Etty about a model amused him:

Dear Constable,

A young figure is brought to me, who is very desirous of becoming a model. She is very much like the Amazon and *all in front remarkable fine.*

Yours &c

W. Etty

The winds were cold and cutting throughout March, and Constable braved them each evening on his way to the Academy where he stayed from five until nine. The model was lit by oil lamps: Constable taught with his usual mixture of good humour and jibes, and on 25 March he made a farewell speech to his students. In this he told the students that the best art schools would always be found in the country which had the best of the living artists, not just the best collections of old master paintings. The students stood and cheered him.

On 30 March he went to a meeting of the Royal Academy's general assembly in the new building of the National Gallery. Afterwards, he walked home with Leslie through the cold but clear night. They passed a crying child who begged them for money, and Constable gave her a shilling and spoke to her until her crying stopped. At the end of Oxford Street Constable and Leslie bade each other a laughing good night and went home their different ways. Next morning, Constable did some work on *Arundel Mill and Castle* and in the evening went out briefly to see to some business connected with the Artists' Benevolent Institution. He came home at nine, had a large supper and as he felt chilly asked for his bed to be warmed. Between ten and eleven he read Southey's *Life of Cowper*; his servant took away the candle when he had read enough and gone to sleep.

The Bather 'at the Doubtful Breeze Alarmed', by William Etty, RA, reveals Etty's taste for statuesque models.

His son John had been out to the theatre, and when he came home he went up to his room, next to his father's, and made ready to go to bed. As he was doing so he heard his father cry out in pain and John went to his side. His father said it was nothing serious; he did not want any medical help. Instead he downed rhubarb and magnesia and then a large quantity of warm water, which made him vomit. He asked John to fetch their neighbour, a Mr Michele. Michele told the servant to bring up some brandy. By the time it arrived Constable was dead.

Next morning, Charles Leslie was getting dressed when he saw Pitt arrive, the messenger who so often brought Constable's letters and notes to him. Pitt asked to see Leslie downstairs. He gave him the message that Constable had died the night before. Leslie went to Charlotte Street with his wife and there he found his friend, in

Constable's death mask. In 1861 Henry Trimmer, an amateur artist, whose father had known Constable, wrote to Turner's biographer Walter Thornbury: 'In height [Constable] was above average; with dark hair and a Roman nose, and a pleasing expression. The likeness of him taken after death by his friend Mr Leslie is not unlike . . .'

The grave of John and Maria Constable in Hampstead parish churchyard. The Latin epitaph means: 'From how slender a thread hangs all that is sweetest in life!'

the attic lined with engravings and one of a moonlight scene by Rubens at the foot of the bed. Next to the *Life of Cowper* lay Constable's watch, which was still ticking.

Leslie expressed his own feelings thus:

I felt his loss far less then than I have since done – than I do even now. Its suddenness produced the effect of a blow which stuns at first and pains afterwards; and I have lived to learn how much more I have lost in him, than at that time I supposed. . . . I have said that Constable was a gentleman, everywhere and at all times, and as much to the humblest as to the greatest people. He even conciliated that untractable class, the hackney coachman; for in his time there were no cabs. He would say on getting into a coach, 'Now, my good fellow, drive me a shilling fare towards so and so, and don't cheat yourself.' . . . Not long after his death, I was coming away from his house, and sent for a coach from the stand near it. When I got home the driver said: 'I knew Mr Constable; and when I heard he was dead, I was as sorry as if he had been my own father – he was as nice a man as that, sir.'

And it is appropriate that Charles Leslie, Constable's devoted biographer, should record the final moments (Mr Judkin, we may recall, was the passionately devoted visitor whom Constable never turned away):

Constable's eldest son was prevented from attending the funeral by an illness, brought on by the painful excitement he had suffered; but the two brothers of the deceased [Abram and Golding] and a few of his most intimate friends followed the body to Hampstead, where some of the gentlemen residing there, who had known Constable, voluntarily joined the procession in the churchyard. The vault which contained the remains of his wife was opened, he was laid by her side, and the inscription which he had placed on the tablet over it,

> *Eheu! quam tenui e filo pendet*
> *Quidquid in vita maxime arridet.*

might well be applied to the loss his family and friends had now sustained. The funeral service was read by one of those friends, the Rev. T. J. Judkin, whose tears fell fast on the book as he stood by the tomb.

ACKNOWLEDGMENTS

The life and work of John Constable has been the subject of much distinguished scholarship. I am aware that I have merely re-assembled the results of some of this to provide a brief narrative account of Constable's life. I have kept the following works in front of me whilst writing this book, and am especially indebted to them: C. R. Leslie's warm-hearted *Memoirs of the Life of John Constable*, edited by Jonathan Mayne (London, 1951); Graham Reynolds' indispensable *Constable: the Natural Painter* (London, 1965) and his *Catalogue of the Constable Collection in the Victoria and Albert Museum* (London, 1960); *The Farington Diary* edited by James Greig (8 volumes, London, 1922–28); and Basil Taylor's *Constable* (London, 1973).

Above all I have used as my main source R. B. Beckett's *John Constable's Correspondence* (6 volumes, Ipswich, 1962–68) and *John Constable's Discourses* compiled and annotated by R. B. Beckett (Ipswich, 1970). R. B. Beckett's edition of Constable's correspondence suggests that a revision of Leslie's version of Constable's life is now necessary. I have followed R. B. Beckett's transcription of Constable's letters and therefore Constable's own mis-spellings have been included. I have also leaned on R. B. Beckett's illuminating commentaries on Constable's letters, life and work. Mr and Mrs Beckett afforded me kindness and encouragement when I was a student and it is a matter of no small regret to me that Ronald Beckett's editorial triumph, published by the Suffolk Records Society, has not been more widely celebrated.

I have also found a number of specialized articles and essays to be of the greatest help, and I owe debts to their authors: Geoffrey Grigson's Preface to *John Constable's Correspondence* (vol. 6, 1968); Martin Hardie's essay on Constable in his *Water-Colour Painting in Britain* (vol. 2, London, 1967); Kenneth Clark's references to Constable in his *Landscape into Art* (London, 1949); Leslie Parris' *Landscape in Britain c. 1750–1850* with an Introduction by Conal Shields (London, 1973), which served as catalogue to the Tate Gallery exhibition of the same name; and, particularly, Michael Kitson's 'John Constable, 1810–1816: A Chronological Study' in *The Journal of the Warburg and Courtauld Institutes* (vol. 20, London, 1957).

I would like to express my gratitude to Mr Malcolm Cormack and Professor Francis Haskell, who have made valuable comments on my work whilst it was under way; and to Mr Michael Rosenthal whose recent unpublished research provides many new insights into Constable's achievements.

1776 John Constable is born in East Bergholt, Suffolk, on 11 June, fourth child and second son of Ann Constable whose husband, Golding, is a prosperous local corn merchant.

1795 Probable date of Constable's first meeting with Sir George Beaumont, whose mother lives at Dedham. Sir George shows Constable Claude's *Hagar and the Angel*.

1796 Constable meets J. T. 'Antiquity' Smith at Edmonton in August.

1798 Probable date of Constable's introduction to Dr Fisher, later Bishop of Salisbury.

1799 Goes to London, is introduced to Joseph Farington, and is admitted as a probationer at the Royal Academy Schools in March.

1800 Is enrolled as student at the Academy Schools on 19 February.

1801 Sketches in Derbyshire in August.

1802 Exhibits at the Royal Academy for the first time.

1803 Journeys from London to Deal in the East Indiaman *Coutts* in April.

1804 Devotes considerable time to portraits commissioned by farmers near his home. Sees Rubens' *The Château de Steen* in collection of Sir George Beaumont.

1805 Is commissioned to paint *Christ Blessing the Children*, altarpiece for Brantham Church, Essex.

1806 Visits Lake District in September and October.

1807 Receives commissions to copy portraits.

1810 Altarpiece, *Christ Blessing the Bread and Wine*, for Nayland Church, Suffolk.

1811 Stays with Bishop Fisher at Salisbury in September, and meets Bishop's nephew, John. Affection for Maria Bicknell is evident but her grandfather, Dr Rhudde, rector of East Bergholt, makes his opposition felt to the engagement. However, Maria's father, Charles Bicknell, permits Constable to write to her. Lodges at 63 Charlotte Street, London.

1812 Summer: sketches in open air in Suffolk.

1813 Works in open air with small pocket sketchbook.

1814 Concentrates on open-air sketching in Suffolk and Essex and fills another pocket sketchbook.

1815 Eight works exhibited at Royal Academy (five paintings and three drawings) which include *Boat-building near Flatford Mill*, painted in the open air. Death of his mother in March. His father gravely ill.

1816 14 May: death of his father. Marries Maria Bicknell, 2

October, at St Martin-in-the-Fields, London. Honeymoon is spent partly with John and Mary Fisher at Osmington in Dorset.

1817 Summer: spends ten weeks at East Bergholt. Birth of his first son, John Charles, on 4 December. Moves to 1 Keppel Street, Russell Square, London.

1819 *The White Horse* is exhibited at the Royal Academy and bought by John Fisher. Birth of his second child, Maria Louise, known as Minna, on 19 July. Rents a house in Hampstead. Is elected Associate of the Royal Academy on 1 November.

1820 *Stratford Mill* exhibited at Royal Academy. Visits John Fisher at Salisbury in July and August. Moves family to Hampstead.

1821 *The Hay Wain* exhibited at Royal Academy. Birth of third child, Charles Golding, on 29 March. Travels with Fisher on latter's Visitation of Berkshire in June and in November visits him again in Salisbury. Family is at 2 Lower Terrace, Hampstead.

1822 *View on the Stour near Dedham* exhibited at Royal Academy. Birth of fourth child, Isabel, on 23 August. Continues close study of skies at Hampstead. Moves town house to 35 Charlotte Street, formerly Farington's residence. Meets French dealer, John Arrowsmith.

1823 *Salisbury Cathedral from the Bishop's Grounds* exhibited at Royal Academy. August: stays with Fisher. In October and November stays with Sir George Beaumont at Cole-

orton, Ashby-de-la-Zouch, Leicestershire.

1824 *The Hay Wain*, *View on the Stour near Dedham*, and *View of Hampstead* exhibited at Paris Salon; *The Lock* at the Royal Academy. His pictures in France awarded gold medal by Charles X. His family stay in Brighton during summer months where Constable visits them.

1825 *The Leaping Horse* exhibited at Royal Academy. Birth of fifth child, Emily, on 29 March. *The White Horse* exhibited at Lille and awarded gold medal.

1826 *The Cornfield* exhibited at Royal Academy. Birth of sixth child, Alfred Abram, on 14 November.

1827 *Chain Pier, Brighton* exhibited at Royal Academy and *The Cornfield* at the Paris Salon. Rents 40 Well Walk, Hampstead. Holidays with John and Minna at Flatford.

1828 *Dedham Vale* and *Hampstead Heath* exhibited at Royal Academy. Birth of seventh child, Lionel Bicknell, on 2 January. Substantial sum of money left to family by Maria's father. On 23 November, death of Maria from consumption, aged 40.

1829 10 February: elected Royal Academician. *Hadleigh Castle* exhibited at Royal Academy. Visits Fishers in Salisbury during July and November for the last time. Begins work with David Lucas on the mezzotint engravings eventually published as *English Landscape Scenery*.

1830 Member of Royal Academy's Hanging Committee. Publica-

tion of first two numbers of *English Landscape Scenery*.

1831 *Salisbury Cathedral from the Meadows* exhibited at Royal Academy. Publication of third and fourth numbers of *English Landscape Scenery*.

1832 Eight works exhibited at Royal Academy including *Waterloo Bridge from Whitehall Stairs*. Publication of fifth number of *English Landscape Scenery*. Death of Archdeacon John Fisher on 25 August.

1833 Seven exhibits at Royal Academy. Gives lecture, 'Outline of the History of Landscape Painting', at Hampstead in June.

1834 Visits Arundel in July and Petworth in September.

1835 One exhibit at the Royal Academy. Second visit to Arundel, in July; at Worcester, in October.

1836 *The Cenotaph* exhibited at Royal Academy. In May and June gives four lectures, 'History of Landscape Painting', at the Royal Institution. In July, second lecture to the Literary and Scientific Society, Hampstead.

1837 At work on *Arundel Mill and Castle*. Dies 31 March. Buried Hampstead Parish Church.

LIST OF ILLUSTRATIONS

18 *A Life Class at the Royal Academy*; engraving by Pugin after Rowlandson, from *The Microcosm of London*, 1808.

19 *Joseph Farington, RA*, miniature by James Nixon. *National Portrait Gallery, London.*

Study of a Male Nude, c. 1800; drawing in black and white chalk on brown paper by Constable. *By courtesy of the Victoria and Albert Museum, London.*

20 *Portrait Drawing*, undated; pencil and watercolour drawing, thought to be a self-portrait by Constable. *National Portrait Gallery, London.*

21 *A Windmill*, 3 October 1802; Black and red chalk and charcoal drawing by Constable. *By courtesy of the Victoria and Albert Museum, London.*

22 Interior of Nayland Church, Suffolk, showing the altarpiece painted by Constable. Photo Tim Stephens.

Christ Blessing the Bread and Wine, c. 1809; altarpiece, oil painting by Constable. Nayland Church, Suffolk.

23 *A Brig at Anchor and Other Shipping in the Thames*, April 1803; pencil drawing by Constable. *By courtesy of the Victoria and Albert Museum, London.*

24 *View in Borrowdale*, 1806; watercolour by Constable. *By courtesy of the Victoria and Albert Museum, London.*

25 *William Wordsworth*, 1818; chalk drawing by Benjamin Robert Haydon. *National Portrait Gallery, London.*

26 *Whitehall, London, from Parliament Street*, 1810; engraving by R. Rosse after G. Shepherd. British Museum, London. Photo R. B. Fleming.

Charles Bicknell, undated; oil painting by Constable. By permission of the Executors of the late Lt. Col. J. H. Constable. Photo Phaidon Press Ltd.

27 *Maria Bicknell*, 1816; oil painting by Constable. *Tate Gallery, London.*

28 *East Bergholt Church*, February 1811; watercolour by Constable. *The Trustees of the Lady Lever Art Gallery, Port Sunlight.*

29 *David Pike Watts, c.* 1806; oil painting by Constable. By permission of the Executors of the late Lt. Col. J. H. Constable. Photo Phaidon Press Ltd.

30 *Archdeacon John Fisher, c.* 1816; oil painting by Constable. *Fitzwilliam Museum, Cambridge.*

32 *Dedham Vale, Morning*, 1811; oil painting by Constable. Collection Sir Richard Proby, Bt. Photo G. Priestman.

33 *Salisbury, Morning*, 1811; oil painting by Constable. Musée du Louvre, Paris. Photo Giraudon.

35 *Thomas Stothard, RA*, undated; pencil drawing by John Flaxman. *National Portrait Gallery, London.*

36 *Landscape and Double Rainbow*, 28 July 1812; oil painting, on paper laid on canvas, by Constable. *By courtesy of the Victoria and Albert Museum, London.*

37 *Mrs Siddons as the Tragic Muse.* Mezzotint after the oil portrait by Sir Joshua Reynolds, 1784.

George Gordon, Lord Byron, 1813; engraving by R. Grave after James Holmes. Newstead Abbey Collections. Reproduced by kind permission of the City Librarian of Nottingham.

38–9 *Four Pages from Sketchbook,* 1813; pencil drawings by Constable. *By courtesy of the Victoria and Albert Museum, London.*

40 Willy Lott's Cottage, at Flatford, as it is today. Photo Tim Stephens.

41 *Willy Lott's Cottage (Willy Lott's House, Near Flatford Mill),* 1813–14; oil painting by Constable. *By courtesy of the Victoria and Albert Museum, London.*

42 East Bergholt Church. Photo Tim Stephens.

Boat-building near Flatford Mill, 1815; oil painting by Constable. *By courtesy of the Victoria and Albert Museum, London.*

43 *East Bergholt Church Porch,* 1814. Pencil drawing by Constable from 1814 sketchbook. *By courtesy of the Victoria and Albert Museum, London.*

44 Constable's visiting-card. Victoria and Albert Museum, London. Photo Eileen Tweedy.

45 *Wimbledon Park.* Pencil drawing by Constable on the back of his visiting card. Victoria and Albert Museum, London. Photo Eileen Tweedy.

46 *Mary Fisher, c.* 1816; oil painting by Constable. *Fitzwilliam Museum, Cambridge.*

47 *Flatford Mill,* 1817; oil painting by Constable. *Tate Gallery, London.*

48 Interior of St Martin-in-the-Fields, London. Photo Sydney W. Newbery, courtesy of Pitkin Pictorials Ltd.

49 *Weymouth Bay,* 1819; oil painting by Constable. Musée du Louvre, Paris. Photo Giraudon.

50 *Wivenhoe Park, Essex,* 1817; oil painting by Constable. *National Gallery of Art, Washington, D.C.*

51 *East Bergholt Church,* 28 October 1818; pencil drawing by Constable. Collection of Sir John and Lady Witt. Photo Courtauld Institute of Art, London.

East Bergholt Church and churchyard, showing the grave of Constable's parents. Photo Tim Stephens.

52 *Royal Academy Exhibition.* Cartoon by I. R. and G. Cruikshank from Pierce Egan: *Life in London,* 1821.

53 *The White Horse,* 1819; oil painting by Constable. *The Frick Collection, New York.*

Death on the Pale Horse, 1817; oil painting by Benjamin West. *The Pennsylvania Academy of the Fine Arts, Philadelphia, Pa.*

54 Memorial tablet to Dr Rhudde in East Bergholt church. Photo Tim Stephens.

Maria Constable with her Two Eldest Children, John Charles and Minna, c. 1820; oil painting by Constable. By permission of the Executors of the late Lt. Col. J. H. Constable. Photo Tate Gallery, London.

55 *Branch Hill Pond, Hampstead,* October 1819; oil painting by Constable. *By courtesy of the Victoria and Albert Museum, London.*

56 *Stonehenge*, 15 July 1820; pencil drawing by Constable. *By courtesy of the Victoria and Albert Museum, London.*

57 *The Young Waltonians.* Mezzotint by David Lucas, published in 1840, after Constable's painting *Stratford Mill.*

58 *William Blake, c.* 1825; drawing by John Linnell. *Fitzwilliam Museum, Cambridge.*

59 *Study of Ash Trees, c.* 1817–19; drawing by Constable. *By courtesy of the Victoria and Albert Museum, London.*

60 *The Hay Wain*, 1821; full-scale oil study by Constable. *By courtesy of the Victoria and Albert Museum, London.*

61 *The Hay Wain*, 1821; oil painting by Constable. *National Gallery, London.*

62 *View of Lower Terrace, Hampstead, c.* 1822. Oil painting by Constable. *By courtesy of the Victoria and Albert Museum, London.*

63 *View on the Stour near Dedham,* 1822; oil painting by Constable. *Henry E. Huntington Library and Art Gallery, San Marino.*

64 *Salisbury Cathedral from the Bishop's Grounds,* 1823; oil painting by Constable. *By courtesy of the Victoria and Albert Museum, London.*

65 *John Charles and Minna Constable Playing in the Nursery, c.* 1822; pen and watercolour sketch by John Constable. Collection Mrs Shirley Fry. Photo John R. Freeman & Co.

66 *John Arrowsmith;* daguerreotype by L.-J.-M. Daguerre. *International Museum of Photography at George Eastman House, Rochester, N.Y.*

68 *Brighton Chain Pier and Promenade. c.* 1828; engraving. British Museum, London.

69 *Brighton: Marine Parade and Chain Pier,* 1824; oil painting by Constable. *Tate Gallery, London.*

Colliers off Brighton Beach (Brighton Beach with Colliers), 1824; oil painting by Constable. *By courtesy of the Victoria and Albert Museum, London.*

70 Self-portrait, undated; oil painting by John Dunthorne the younger. *Ipswich Borough Council.*

71 Constable's London; detail of a map of 1832. *The Greater London Council Print Collection.*

72 Cartoon by George Cruikshank, attacking agitators for reform, 1819. Photo John R. Freeman & Co.

74 *The Leaping Horse*, 1825; oil painting by Constable. *Royal Academy of Arts, London.*

75 *Emily Constable,* undated; pencil drawing by Constable. By permission of the Executors of the late Lt. Col. J.H. Constable. Photo Phaidon Press Ltd.

John Charles Constable, undated; oil painting on board by John Constable. *Roy Miles Fine Paintings, 6 Duke Street, London SW1.*

77 *Study of Sky and Trees, c.* 1821; oil painting by Constable. *By courtesy of the Victoria and Albert Museum, London.*

79 *The Cornfield,* 1826; oil painting by Constable. *National Gallery, London.*

80 *Seascape Study with Rain Clouds, c.* 1824–28; oil sketch

by Constable. *Royal Academy of Arts, London.*

81 *John Charles and Minna Constable Boating while on Holiday at Flatford,* 1827; pencil sketch by Constable. Photo Fogg Art Museum, Harvard University.

82 Constable's house in Well Walk, Hampstead. Photo Tim Stephens.

83 *Dedham Vale,* 1828; oil painting by Constable. *National Gallery of Scotland, Edinburgh.*

84 Self-portrait, undated; oil painting by Charles Robert Leslie.

Harriet Leslie, undated; drawing by Charles Robert Leslie.

85 *Portrait, believed to be of Maria Constable, c.* 1827; oil painting by Constable. Formerly private collection, Scarborough. Photo Edwin Smith.

86 *A Boat Passing a Lock,* 1826; oil painting by Constable. *Royal Academy of Arts, London.*

87 *Hadleigh Castle,* 1829; oil painting by Constable. *From the Collection of Mr and Mrs Paul Mellon.*

88 *Water-meadows near Salisbury,* 1829; oil painting by Constable. *By courtesy of the Victoria and Albert Museum, London.*

89 *David Lucas, c.* 1820; portrait miniature attributed to R. W. Satchwell. *National Portrait Gallery, London.*

Summer Morning, Dedham Vale, undated; mezzotint by David Lucas after painting by Constable.

90 *Study of a Winding River Valley,* 1830; pen and brown

wash drawing by Constable. *Fitzwilliam Museum, Cambridge.*

91 *John Constable Late in Life,* undated; pencil drawing by Daniel Maclise. *National Portrait Gallery, London.*

92 *Salisbury Cathedral from the Meadows,* 1831; oil painting by Constable. *Collection Lord Ashton of Hyde.*

A Dog Watching a Rat in the Water, Dedham, 1 August 1831; pencil and watercolour drawing by Constable. *By courtesy of the Victoria and Albert Museum, London.*

93 *A Mouse with a Piece of Cheese, c.* 1820–30; oil painting by Constable. *Courtesy of the Trustees of the British Museum.*

94 *J. M. W. Turner,* 1816; pencil drawing by C. R. Leslie. *National Portrait Gallery, London.*

95 *Lord Chancellor Brougham at the Coronation of William IV,* sketch by Constable from R. B. Beckett (ed.), *John Constable's Correspondence,* Vol. III, Suffolk Records Society, Ipswich 1962–68.

96 *Waterloo Bridge from Whitehall Stairs,* 1832; oil painting by Constable. Private collection.

97 *Helvoetsluys,* 1832; oil painting by J. M. W. Turner. Private collection.

Turner on Varnishing Day, c. 1846; oil painting by S. W. Parrott. *University of Reading (Guild of St George and Ruskin Collection).*

99 *John Fisher and his Dogs,* 22 July 1829; ink and watercolour

sketch by Constable. *By courtesy of the Victoria and Albert Museum, London.*

100 Half-title of *Songs Divine and Moral* (1832) by the Rev. Isaac D. Watts, decorated by Constable as a birthday present for his daughter Emily in 1833. Victoria and Albert Museum, London. Photo Eileen Tweedy.

101 Front page of a letter dated 27 March 1833 from Constable to his eldest son John Charles. Victoria and Albert Museum, London. Photo Eileen Tweedy.

103 *Christopher Columbus Explaining the Project for the Discovery of the New World, in the Convent of La Rábida,* 1834; oil painting by Sir David Wilkie. *Collection of the North Carolina Museum of Art, Raleigh, gift of Hirschl and Adler Galleries, New York.*

104 Arundel Castle, taken from the same viewpoint as that of Constable's *Arundel Mill and Castle.* Photo Tim Stephens.

105 *Arundel Mill and Castle, c.* 1836–1837; oil painting by Constable.

The Toledo Museum of Art, Toledo, Ohio, gift of Edward Drummond Libbey.

107 *The Valley Farm,* 1835; oil painting by Constable. *Tate Galley, London.*

108 *View of the Stour, Dedham Church in the Distance, c.* 1830–36; pencil and sepia wash drawing by Constable. *By courtesy of the Victoria and Albert Museum, London.*

109 *Charles Constable,* September 1835; oil painting by Constable. Private Collection. Photo courtesy of Carlos Peacock.

111 *The Cenotaph at Coleorton, in Memory of Sir Joshua Reynolds, c.* 1836; oil painting by Constable. *National Gallery, London.*

113 *The Bather 'At the Doubtful Breeze Alarmed', c.* 1848; oil painting by William Etty. *Tate Gallery, London.*

114 Grave of John and Maria Constable in Hampstead Cemetery. Photo Tim Stevens.

115 Bronze cast of Constable's death mask. *National Portrait Gallery, London.*